# Recollections

## A LIFE IN BOOKBINDING

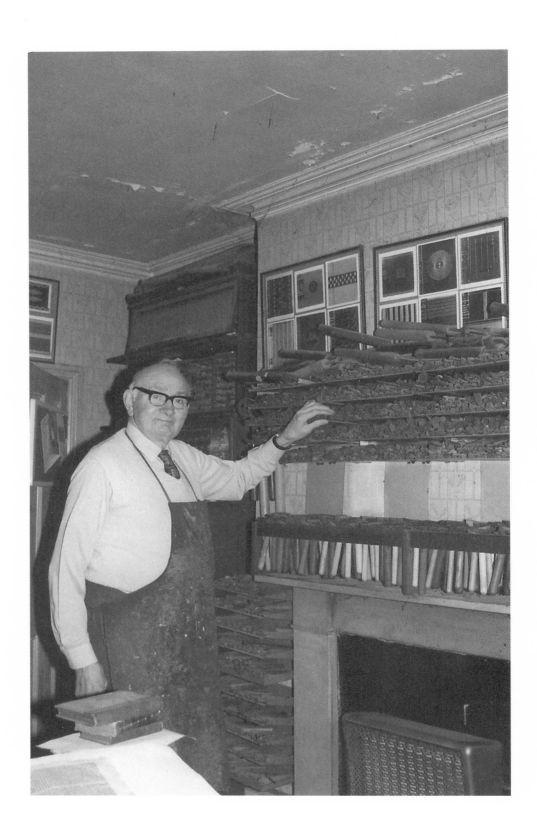

BERNARD C. MIDDLETON

# Recollections

## A LIFE IN BOOKBINDING

*With a Foreword by*
*Dr. Marianne Tidcombe*

Oak Knoll Press &
The British Library
2000

First Edition.

Published by **Oak Knoll Press**
310 Delaware Street, New Castle, Delaware, USA
and **The British Library**
96 Euston Road, St. Pancras, London, NW1, UK

**ISBN:** 1-58456-016-9 (USA)
**ISBN:** 0-7123-4683-X (UK)

Title: Recollections
Author: Bernard C. Middleton
Typographer: Shadow Canyon Graphics
Editor: Susan Rotondo
Director of Publishing: J. von Hoelle

Cover: A gold-tooled on leather design in tribute to Bernard Middleton by Michael Wilcox.

**Library of Congress Cataloging-in-Publication Data**
Middleton, Bernard C., 1924-
    Recollections : an autobiography of Bernard C. Middleton.
       p. cm.
    Includes bibliographical references.
    ISBN 1-58456-016-9
    1. Middleton, Bernard C., 1924-  2. Bookbinders—Great Britain—Biography. 3.
Books—Conservation and restoration—Great Britain—History—20th century. I. Title.

Z269.2.M53  A3  2000
686.3'0092—dc21
[B]                                                                                    99-088180

*British Library Cataloguing-in-Publication Data*
A CIP Record is available from The British Library

Printed in the United States of America on 60# archival, acid-free paper meeting the require-
ments of the American Standard for Permanence of Paper for Printed Library Materials.

# PUBLISHER'S PREFACE

I first met Bernard Middleton some years ago when I asked him for permission to republish a revised and expanded edition of his *History of English Craft Bookbinding Technique*. This classic was first published by Hafner Publishing in 1963 and I wondered if he would like to update this important work. To my delight he agreed and over the next months I received more than sixty additional pages of text and many new illustrations. I was so impressed with the new edition that I called David Way at the British Library and asked him to join Oak Knoll in co-publishing the book. He did and the new edition quickly became a best seller in the sometimes arcane but scholarly world of binding enthusiasts and practitioners.

The following year I asked Bernard if he would revise and expand his other scholarly work, *The Restoration of Leather Bindings*. This excellent book on conservation techniques was first published in 1972. Once again Middleton set about rewriting the text and offering additional illustrations. At this time I met Bernard's close friend, Dr. Marianne Tidcombe, a scholar and author on bookbinding history in her own right. She and I edited the new edition and shared a love of good writing and fine, handmade bindings. I found her standards of editing, research and scholarship were as meticulous and demanding as Bernard's. The new *Restoration* was published early in 1998 to critical acclaim. It is now in the second printing of its third edition and has been translated into Spanish.

Shortly after, Marianne brought to my attention that Henry Morris of the Bird & Bull Press had printed a fine press, limited-edition autobiography of Bernard's in the early 1990's. Upon return to the States, I called Henry, the unofficial "God Father" of Oak Knoll, and asked if we could reprint his work. In Henry's charming curmudgeon-style, permission was granted and a set of text was sent me. However, after reading it, I believed there was much more to Bernard Middleton than was first revealed in this thin but beautifully printed book. Once again I asked Bernard if he would expand the text of his earlier autobiography with more details of his life, especially on his early training and the people who had inspired him. His reply was pure Middleton, "John, I don't think anyone would be interested. I'm not a war hero or anyone very important." I remember replying, "Bob and I don't publish books about warriors or politicians. We publish books about the books arts and the talented people who have mastered

iii

them." He shrugged his shoulders and gave me a look as if saying, "Well, if you want to waste your money."

I remember sitting down with him one evening at his dinning room table and sorting out the additional pictures for the new edition. While going through the hundreds of old black and white photos I noticed a small box of color slides. "What are these?" I asked out of sheer curiosity. "Just some of my old bindings," he replied nonchalantly. I took several out and held them up to the light. The first one was a crimson leather binding with a magnificent gold-tooled, spiral design. One by one I held up the slides to the light and marveled at the intricate patterns and designs Bernard had created over a life time. "I would like to put some of these in the book," I blurted out. "Can you select some for me?" "The detail won't show up very well in black and white," he reminded me. "I know," I answered, "how about we do the best ones in color?" He looked at me with raised eyebrows and simply said, "That would be very nice."

For the next four days, I attended the London Book Fair and Bernard agonized over which forty-six slides to select for the color signature. He started with more than 200 slides scattered on a light table. Each day, as I returned to his Victorian town house, he had whittled down the 200 to 100, then to 70 and finally to 46. As he reluctantly removed each slide, I believe he was painfully aware that another work of art would not be illustrated in the eight page color signature. For him, this exercise must have been like throwing loved ones overboard to lighten the load in a lifeboat. Several months later the new manuscript was edited and typeset. I selected a beautiful gold-tooled design created by Michael Wilcox for the dust jacket and wrote the final flap copy. David Way found some funds in his budget and let me know the British Library wanted to co-publish the book.

At this time, Bernard's considerable library on bookbinding was being removed to the Rochester Institute of Technology and working on his autobiography helped to ease the absence of his beloved books.

During these years of close literary cooperation, I grew to appreciate and admire the quiet dignity of this man and his dry British humor. I discovered he was not only a gifted binder and writer, but a gracious host with a grand sense of British humor. I will never forget his warm hospitality and the meals we shared, many he personally cooked. Other fond memories that come to mind are the fun-filled evenings spent at *Rules*, his favorite restaurant, and then on to *The Players' Theatre* for a bit of Victorian song and laughter.

For the thousands of people around the world who have listened to this gentle man's lectures, read one of his books, or are fortunate enough to own a binding by him, Bernard's autobiography will be a special experience. This unassuming book captures a bygone age and a rare personality. For Bernard Middleton is that unique combination of author, scholar, craftsman and conservator that I find so rare today. And to hold in your hands one of his superb bindings, is to touch the work of a master in his field.

J. Lewis von Hoelle
New Castle, Delaware

# ACKNOWLEDGEMENTS

I am greatly indebted to the redoubtable Henry Morris, letterpress printer and proprietor of the renowned Bird & Bull Press, because without his initial enterprise early in 1994, the Fine Press edition of *Recollections* probably would not have been produced. Robert Fleck has my gratitude for publishing this revised and expanded edition, which will be available for a wider readership. John von Hoelle's customary courtesy and helpful co-operation greatly eased the burden of authorship.

This is a convenient place in which to record my indebtedness to David Pankow, Curator of the Melbert B. Cary, Jr. Graphic Arts Collection at the Rochester Institute of Technology, N.Y., for his friendship and co-operation over a twenty-year period.

No single aspect of my life, whether it be in the craft or outside it, has been in any way outstanding or remarkable, but I do hope that as one who has devoted himself to his craft on a fairly broad basis over a period of more than sixty years, my experiences will have some interest for young people whose own are very different. Perhaps, too, my reminiscences will have resonances for some of the more elderly practitioners of a fascinating and very demanding craft.

# TABLE OF CONTENTS

Acknowledgements . . . . . . . . . . . . . . . . . . . . . . . . . . . . . . . .v
Foreword by Dr. Marianne Tidcombe . . . . . . . . . . . . . . . . . . . . . . .ix
The Early Years . . . . . . . . . . . . . . . . . . . . . . . . . . . . . . . . . .1
The War Years . . . . . . . . . . . . . . . . . . . . . . . . . . . . . . . . . . .9
My Education Continues . . . . . . . . . . . . . . . . . . . . . . . . . . . . . .21
A Business of Our Own . . . . . . . . . . . . . . . . . . . . . . . . . . . . . .35
A Home of Our Own . . . . . . . . . . . . . . . . . . . . . . . . . . . . . . .47
America and Beyond . . . . . . . . . . . . . . . . . . . . . . . . . . . . . . .65
End Notes . . . . . . . . . . . . . . . . . . . . . . . . . . . . . . . . . . . .81
Descriptive captions for colour illustrations of bindings . . . . . . . . . . . .85
Descriptive captions for the B&W bindings illustrated . . . . . . . . . . . . . .91
Colour illustrations of Middleton's bindings . . . . . . . . . . . . . . . . . . .95
Middleton's bindings illustrated in B&W . . . . . . . . . . . . . . . . . . . .105
Appendices:
    A mid 20th century apprenticeship indenture . . . . . . . . . . . . . .112
    London School of Printing Class Report . . . . . . . . . . . . . . . .115
    A final written examination for bookbinding . . . . . . . . . . . . . .116
    A final "practical test" . . . . . . . . . . . . . . . . . . . . . . . .118
    A City & Guilds of London Institute Certificate . . . . . . . . . . . .119
    General Eisenhower's D-Day Declaration . . . . . . . . . . . . . . . .120
    Article *"Scale in Bookbinding"* 1950 . . . . . . . . . . . . . . . . .121
    Article *"The British Museum Bindery"* 1953 . . . . . . . . . . . . . .124
Bibliography . . . . . . . . . . . . . . . . . . . . . . . . . . . . . . . . . .127

# FOREWORD

Worthy books about bookbinding are few and far between, and informative books about binders are even thinner on the ground. The memoirs of an important binder is a rare item indeed. Imagine the delight if Roger Payne had left us the story of his eventful life, rather than only his lengthy bills. It is unlikely that binders of the past would have been able to write such a book, however, because they were bench-men, and usually barely literate. It is partly for this reason that we generally attribute famous bindings to the employer, a binder in name only, rather than to the real binder. Some binders, usually self-styled artists, have written books in mid-career to boost their image, because they fear posterity will not judge them as highly as they judge themselves. Nothing could be further from the truth in the case of Bernard Middleton. He is an excellent binder, and also a superb writer.

His *Recollections* is the quietly written story of a man who has devoted his life to restoring fine books to soundness and beauty. In it, he traces his career from hesitant apprentice at the British Museum Bindery, to teacher at the Royal College of Art, and then to manager of Zaehnsdorf's. Later, one reads with sympathy how he and his wife Dora struggled to build up a business of their own. Vignettes from his life in the navy during the war, commissions from the great and the good, and ultimately an invitation to Buckingham Palace to receive an honour from the Queen are all told with a wit and humility that is typical of the man. It is a captivating story from beginning to end. The easy flow of the narrative gives one the feeling that he sat down one evening to reply to a question about his early life, and was not allowed to get up until he reached the present.

Bernard was born to the trade of bookbinding. His father, who was

at the London County Council's Central School of Arts and Crafts with William Matthews, was a forwarder at Sangorski & Sutcliffe. However, unlike most binders, Bernard took a scholarly interest in what he saw when working on books, and his memory of so many thousand details was recorded and published for our benefit. His *History of English Craft Bookbinding Technique*, now in its fourth edition, is indispensable to anyone writing on binding history. The history of bookbinding is a vast and fascinating subject, and only parts of it can be understood with any thoroughness in a lifetime. Original research can be so time-consuming and frustrating that after a while many capable scholars have felt obliged to give up the chase. For some, discovering new facts and solving an occasional mystery are satisfying enough, but work in this field brings little in the way of other rewards. There are no university chairs in the subject, published works are read by a small, even if distinguished, group of people, and the financial returns are minimal. It is therefore not surprising that the study of bookbinding has so seldom been approached with any kind of method or rigour. Bernard Middleton is one of the few to have done so. He learned to write at a time when teachers cared about the precise use of words and the construction of sentences, and he has the gift of being able to explain the most complicated procedure in a clear and logical way. These skills were of the utmost importance when he was writing his manual, *The Restoration of Leather Bindings*, the third edition of which appeared last year. It is a book of such excellence that, like Douglas Cockerell's *Bookbinding and the Care of Books*, it will continue to be useful a hundred years from now.

As well as being the most skilful book restorer at work today, Bernard has, during the same period, produced an impressive number of gold-tooled design bindings of great elegance. Because he is both an expert forwarder and finisher, his bindings are a delight to handle, and a pleasure to the eye. Howard Nixon accurately described him as 'essentially a binder who designs rather than a designer who also binds'. The decoration is always an integral part of the structure of the binding, and never gives the appearance of a design merely stuck on to the covers. Because Bernard never attempts to go beyond the traditional limits of good bookbinding design, his bindings, though clearly belonging to the latter half of the twentieth-century, are wholly in keeping with what are deemed the finest bindings of all periods.

In 1951, when Arthur Johnson and a few art-school-trained binders

formed a small Guild to exhibit their work, they asked Bernard Middleton, already an established binder, to join them. A few years later, this group became the Guild of Contemporary Bookbinders, and later, Designer Bookbinders. Throughout its history, Bernard has supported the society by exhibiting his bindings, sitting on committees, serving as President, and, jointly with myself and others, editing *The New Bookbinder* for several years. Many times I have pointed Bernard out as 'the tall gentleman at the back of the hall' to a nervous young binder who came to a meeting hoping to ask for advice on some difficulty he was having with a book. I have never known Bernard to put anyone off, no matter how inexperienced the questioner might be. Like a good doctor, he has patiently listened to the young binder's problems, and given freely of his advice.

It was about thirty years ago that I first met Bernard, when I was doing a little bookbinding myself, and we later worked together on projects for Designer Bookbinders. However, it is since I gave up binding and turned to research that he has been of the greatest help to me. There have been times when I felt his fine library on the history of bookbinding was as useful to me as it had been to him. Occasionally, he has kindly searched his bookshelves late at night, 'bookworming in pyjamas', mobile phone in hand, to help me find the answer to some vexing question. We have taken excursions to various parts of London, and sometimes farther afield, to see where famous binders have lived or worked. When out walking, like most people who accompany Bernard, I have found it difficult to keep up with his giant strides! Among Bernard's greatest pleasures have been his trips to America, where, separated from his bench and correspondence, he has tried to relax fully and to do some of the things he has no time for in London. He told me that, on one occasion in California, he even drove a motor car; however, I gather it was only round an empty car park.

Having reached his seventy-fifty birthday this year, Bernard has vowed to cut down on his work, although sometimes it seems to me that he is busier than ever. However, his life has changed in three important respects. He has had to make a number of adjustments following the death of his wife Dora two years ago, including re-housing the last two of the many Middleton cats, and learning new skills in the kitchen. More recently, his part-time assistant, the talented Flora Ginn, left his bindery after twelve years to work entirely on her own. However, her bindery is in her home nearby, and she remains a devoted friend and colleague. Many years ago, Bernard arranged to sell his collection of books and items relat-

ing to the history of bookbinding to the Rochester Institute of Technology (R.I.T.) in upstate New York, and, at the time of writing, his library is being packed for shipment to America. R.I.T. is marking the acquisition with a conference in Bernard's honour, 'Bookbinding 2000', next year. Following his workshops in the U.S.A., he has made many good friends there, and he now has this further permanent connection with America.

The departure of his library will not leave Bernard's house in Clapham entirely devoid of books. Those on general and non-bookbinding subjects, which have hitherto been stacked on tables and on the floor, will now occupy the shelves; and I suspect he will continue to buy some new bookbinding titles as they appear, and old ones which specially interest him. In addition to his two major books, Bernard is also the author of many articles on bookbinding and related subjects, and, as someone singularly qualified to do so, he has written a number of forewords, introductions, and reviews for other people's books on binding and marbling. At one time, he began a book on the various materials, techniques, and procedures used in binding, which would be of immense value to librarians and rare book curators, who are often at a disadvantage when they have to deal with bookbinders. Although Bernard claims this book will never be completed, as the scope is too great, I remain hopeful that parts of it, at least, will be published one day. A few weeks ago, he brought home a new i-Mac computer, which reinforced my belief that he will not give up writing entirely. A considerably more animated recent addition to the household is a delightful little black kitten Bernard has named 'Caxton'.

*Marianne Tidcombe*
*Walton-on-Thames*
*November 1999*

# THE EARLY YEARS

Apart from a spell of three years in the Royal Navy (two during the Second World War, and one afterwards), my professional life has been wholly concerned with craft bookbinding and restoration. Even earlier, I was very much aware of the craft because my father was a professional forwarder and I did a little binding at the age of twelve at Senior School; the multiplicity of elementary binding manuals published in the 1920s and 1930s testifies to the popularity of the craft as a school subject.

I was born in East Dulwich, London, in October 1924. My maternal grandfather, Frederick Webster, a master builder, constructed schools, branch banks, houses and, according to my mother, a wing of the Tate Gallery. In the house he built for the family in Peckham, he employed a cook and a maid. Grandmother was a member of the de Freyne family. A Judge and a Master of the Clockmaker's Company were numbered among their close relatives, so that side of my family was quite prosperous. Not so the other side. My paternal grandfather (fig. 1) was a postman in his early days and delivered mail to the house of Charles Dickens, whom he often met. According to a local newspaper report, published on the occasion of my grandparents' golden wedding anniversary, he delivered mail on the day of Dickens' death in 1870 and was given a button-hook as a memento. Later, grandfather was a butler, but he ended up as a company secretary in the City with what, I think, must have been a small company. Grandmother[1] was a cook, apparently with one or more grand families because she spoke of cooking for the Prince of Wales when he was a guest.

My father (fig. 2), Regent Marcus Geoffrey, was born in 1898. He won a Trade Scholarship which took him to the Central School of Arts

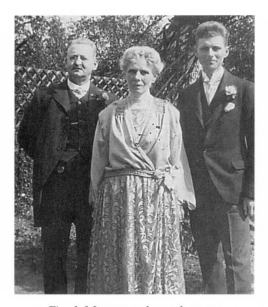

*Fig. 1.* My paternal grandparents with my uncle, Adrian.

and Crafts in Southampton Row, London, in 1911, where he chose to take up bookbinding—the other two possibilities being printing and silversmithing. I am very pleased that he opted for the craft that obsesses so many of its practitioners and that we all find so difficult to master; it is almost certain that if my father had gone into silversmithing, say, I would now be hammering metal. A contemporary of my father at the Central School was William F. Matthews (fig. 3) who, about twenty-five years later, taught me in the same room. All three of us were taught by Peter McLeish whose father, Charles, had executed all the gold tooling at T. J. Cobden-Sanderson's Doves Bindery. One of my father's slightly older contemporaries at the Central was Alex J. Vaughan, a star student who later produced many designs for Sangorski & Sutcliffe. My father's one and only literary effort appeared in the *Boys' Magazine* in 1913 (figs. 3a & 3b).

He joined the Territorial Army under age in 1914 and served overseas, principally in Salonika with horse-drawn artillery. Before service, he won the City and Guilds of London Institute's Bronze Medal and the Stationers' Company's Silver Medal for Forwarding in 1913. For a brief period before volunteering for war service, he was apprenticed to W. T. Morrell as a forwarder, and

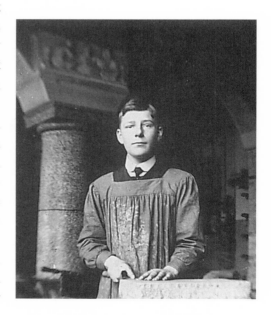

*Fig. 2.* My father, Regent Middleton, at the Central School of Arts and Crafts, c. 1913.

2

Matthews also went there, but as a finisher. It was one of the largest fine binderies in Britain, and had a reputation for 'slave-driving'. It catered largely for the book trade and produced vast numbers of school prize bindings in gold-tooled calf or tree-calf at remarkably low cost—four shillings in about 1910. That said, Morrell's could also create elaborately decorated bindings of the finest technical quality. When my father was demobilized in 1919 they refused to take him back, but Sangorski & Sutcliffe took him on for the completion of his apprenticeship, and apart from a break of ten years remained with them until his retire-

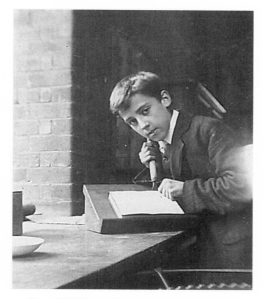

*Fig. 3.* William Matthews at the Central School of Arts and Crafts, c. 1913.

ment at the age of seventy-five. The move was fortunate because 'S. & S.', as they were commonly known, was the better bindery with a much more prestigious clientele. William Matthews had also joined the army under age, but returned to Morrell's after the War and stayed until 1926, subsequently becoming one of Britain's very best fine binders and teachers.

In the early 1920s, my father met my mother, Doris Hilda Webster (b. 1897) in the gardens of the Horniman Museum, at Forest Hill, South London, and in due course married her. Mother left school at the age of seventeen with a working knowledge of French and the ability to play the piano, a talent she used to entertain wounded servicemen in Dulwich Hospital. Following a course at a Secretarial College she worked at the Air Board in Kingsway, and then became secretary to Stafford Cripps, a well-known barrister who later became Sir Stafford, and Chancellor of the Exchequer in a Labour Government.

I joined the Cubs in East Dulwich and managed to attain the status of 'sixer', though this was after such a long period that it gave rise to comment, and by dint of parental pressure I attended Sunday School at the Congregational Church. I do try to "Be prepared" as the Scouting movement hopes, but I have hopelessly failed the Congregationalists.

THE CENTRAL SCHOOL OF ARTS AND CRAFTS

# BOYS' MAGAZINE

A JOURNAL FOR THE BOYS OF THE DAY TECHNICAL
SCHOOLS of BOOK PRODUCTION & SILVERSMITH'G
No. 18, Vol. III. June 17th 1913. Price ONE PENNY.

The Rt. Hon. David Lloyd George
Wood-block drawn and cut by Ll. T. Lewis

## SLUG-HUNTING

By R. Middleton

Why go to Africa for big game hunting, or Scotland for partridge shooting, when you can have the pleasure of killing slugs in the garden ? Slugs are slimy and dirty, so it is advisable to have your supper before going slug-hunting as they might put you off your food.

The quickest way of killing slugs is to stand on them. Besides being the quickest, it in a way, atones for the damage the slugs did to the garden. Salt will kill slugs, but it is not satisfactory. The best time to go slug-hunting is about 9 p.m., so you will have to water the garden at 7 p.m. or earlier.

My biggest "bag" was on May 17, when I caught 210, and my second biggest a week later.

*Fig. 3a (left).* The cover of *Boys' Magazine*, produced at the Central School.
*Fig. 3b (right).* My father's contribution to *Boys' Magazine*.

Early in 1938, after an undistinguished school record[2], I contrived to win a Trade Scholarship (as my father and Matthews had done), which enabled me to attend the Central School at reduced cost. The school provided general education[3] and vocational training, about half and half, and two and a half years there counted as two years of a seven-year apprenticeship. Two of the teachers in history and science had doctorates, so the level of education was somewhat higher than that found in Elementary Schools, as they were then known. My lack of academic vigour continued at the Central School. On the one occasion I contrived to come top in a class test, the history teacher challenged the rest of the class to guess who had so distinguished himself; needless to say, no one came up with my name.

In addition to William Matthews, who taught part-time and was otherwise self-employed, and Peter McLeish[4] who was in charge of the 'trade boys', as we were known, I was also taught by George Frewin (fig. 4) who worked at Sangorski's most of the time. The Bookbinding Room was very large and divided by a glass screen. On one side, amateurs and a few non-trade professionals (virtually all of whom were middle-class) such as Elizabeth Greenhill, were instructed by Douglas and Sydney Cockerell, Matthews and others. On our less genteel side, the trade boys got up to jolly japes and did unmentionable things to each other with fully

charged paste brushes. I am thankful, as one who was on the receiving end of the treatment, that there were no spirit stains in the department. Although separated by only a few feet, the two groups were worlds apart and each ignored the other. In our youthful exuberance we threw around wads of wet cotton wool, some of which stuck to the ceiling, and I recall now with a slight *frisson* the occasion when I launched a missile and it landed, inadvertently, in the middle of the back of Frewin's beige warehouse coat and he turned round with a baleful glare. Such a trivial event, but I was even more timid then than I am now, so the memory stays with me in a neurotic way.

Matthews (fig. 5) was quite stern and I was somewhat afraid of him. I well remember being lined up with the other boys at the start of the first day, when he turned to me and growled in his gravelly voice, "Roll up your sleeves, boy." I cringe as I recall the occasion when he instructed me to pencil glaire into blind impressions for later gold tooling, and I proceeded to sort out a lead pencil for the task. Clearly, I was not the star turn of the class of '38.

*Fig. 4.* A group of binders on the roof of Sangorski & Sutcliffe's, 1-5 Poland Street, London, probably early 1930s. Front row, from the left, Arthur Coombs, George Durham, George Frewin. My father, in the light suit, is in the centre of the group. Ted Turner (second from the left in the back row), one of the finest finishers in the country, was best man at my parents' wedding.

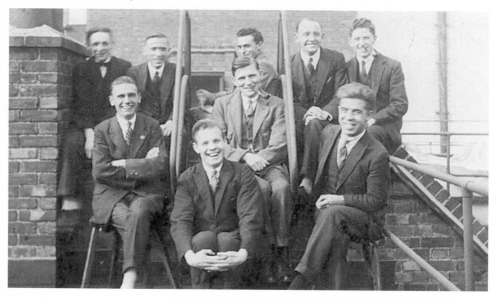

*Fig. 5*
William Matthews
(1898–1977)
late in life.

My first of many major embarrassments of a bibliopegic nature occurred while I was at the Central School; I proudly took home a book I had bound in quarter-goat, library style, and showed it to a family friend who flipped through it and immediately spotted that a section was upside down. Oh, such mortification.

I had my first sight of fine modern French bindings during this period when we were taken as a class to see an exhibition in the Vestry (in Little Russell Street, nearly opposite McLeish's bookshop) of St. George's, Bloomsbury, which was put on by the First Edition Club. The show was dazzling and it made a strong impression on me.

The head of the Printing Department was J. H. Mason (1875–1951), a very remarkable scholar-printer who left school soon after he reached the age of twelve years and eventually became Cobden-Sanderson's chief compositor at the Doves Press. He was able to read Latin, Greek, French, German, Italian, Sanscrit, Russian, Chinese and other languages. Mason started full-time teaching at the Central School in 1909 and remained there until 1939 when we were evacuated to Newbury, in Berkshire. My father received some instruction from him, but twenty-five years later bookbinding students were not given this insight into printing practice, so

I missed out. I spotted him at an exhibition of typography in the Victoria & Albert Museum a few months before he died in 1951, and felt compelled to approach him. Of course, he did not remember me and had no reason to do so because we had not actually met when I was a student, and he could not be expected to remember my father, a part-time student before the First World War.

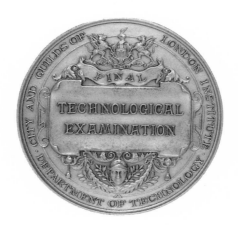

First prize silver medal awarded in 1943, by the City & Guilds
of London Institute, for Forwarding. Bernard's name
is engraved around the edge.

# THE WAR YEARS

At the beginning of September 1939, at the outbreak of the Second World War, we were evacuated with McLeish and Matthews as teachers to Newbury, where we were billeted with various families around what was, at that time, a very pleasant old market town. The bindery was a makeshift affair in a former shop and the silversmiths were in an adjacent room, so we had to endure a good deal of hammering. The first winter of the war was very icy, and the unfamiliar blackout in that quiet town took some getting used to, but I have very happy memories of that period; the roads were nearly empty and we went for long cycle rides in the surrounding countryside, led by the sports master on his autocycle. Matthews took us on hikes to a number of prehistoric sites such as the Vale of the White Horse. These experiences strengthened my incipient interest in the past, which has remained with me and grown stronger.

In the spring of 1940, not long before the start of the Blitz (which I had been evacuated to escape), I returned to London to start my apprenticeship at the British Museum Bindery, which was run by HMSO [see Appendix A]. My father was already there (although part of the time he was seconded to work with Censorship, which was accommodated in the Prudential Building in High Holborn) having moved over from Sangorski's in the mid-1930s for security of employment. It was he who arranged for me to be indentured. I was fortunate to have this connection because some fellow students who lacked such help were sent off to obscure binderies with comparatively low standards.

As soon as I arrived at the Bindery in a yard behind the British Museum's main building, I was required to sign the Official Secrets Act. It made me feel frightfully important, but of course I was never burdened

with any secrets. In my first year I was paid £1 per week, in my second £1.6s.8d., and in my third £1.12s. But for later events, this would have risen to £2.4s in the fifth year.

As I was the most junior apprentice it was one of my first tasks to paste mull (thin muslin fabric) over all the many windows to reduce the horrific effects of splintering in the event of bomb blast. The Museum was indeed bombed, with considerable damage to books, but not to the Bindery's windows. On the occasions when I now walk through the immaculate King Edward VII Gallery at the rear of the Museum my mind goes back to the time, fifty-seven years ago, when it was stacked with scores of thousands of damaged books, some charred, others sodden with water. It was a chaotic scene and the air was filled with the smell of burnt paper. As I recall, all I had to do was help sort things out with some girl sewers who were also drafted in from the Bindery. This, my first experience of mass book destruction, did not unduly depress me as it would now; indeed, I suspect that it was a welcome relief from the normal daily routine, so I must have been a callow youth.

When bombing caused disruption of gas supplies, I had to help with the maintenance of a brazier in the yard outside the Bindery so that hot drinks could be made. Another of my tasks as a junior was to help one of the porters boil the paste in a huge cauldron with the aid of a long wooden paddle which had to be wielded with both hands and arms at full stretch. I also delivered bound books on a trolley to the various departments throughout the Museum. This sometimes involved the use of huge, anti-quated and ponderous hydraulic lifts which one could activate by pulling on a rope. It was on one of these trips in 1940 that I first became acquainted with the celebrated round Reading Room for which I have ever since had great affection, and for which I have had a reader's ticket during the past fifty years. I was one of many sad readers—some tearful—who were present on the day it closed, October 25, 1997, in preparation for the move to the new British Library building about a mile away. However, I digress.

From time to time, as a boy, I was required to deliver things to the Foreign Office, a welcome excursion which necessitated my walking into Downing Street, off Whitehall. It was such a long time ago that I can admit without blushing that I hoped to be mistaken for someone on a mission of national importance. Sometimes, at lunchtime, there was light relief which took the form of larking about with the girl sewers in the

Board Room, a little-used room which was filled with shelves for mill-boards of various traditional sizes and thicknesses such as Foolscap 6d or Crown 8xx. Much of the board was hand-made with rope-fibre, production of which ceased in 1939, regrettably.

At the Central School (fig. 6) I had progressed to half- and full-leather work, but my early experiences as an apprentice were deflating, and justifiably so because, as is still the case in college courses, one runs before one can walk. As was then the case in many other trades, when one left technical school and started out in the hard 'real' world, one was told to "forget what you have been told at school, *this is what we do!*" For weeks on end I had to make 'made' endpapers with beige Cobb paper. This was not the simple task it sounds to be because one was expected to have built up quite a pile of pasted papers before making a move towards the nipping-press, and the very stretchy and thin Cobb paper tended to make creases. My lack of success when I started, and severe criticism by the foreman, Charlie King, who had worked with my father at Sangorski's in the earlier years, and whom I had known as a child, worried me greatly, but I got through it.

For something like two years I worked only on buckram bindings which at that time had laced-in boards. It was boring work, and also frus-

*Fig. 6.* The Central School of Arts & Crafts, London, 1994.

trating because I was keen to improve my skills and gain experience, and pride was also a factor. At one stage I asked my mentor, Arthur Coombs, also formerly of Sangorski's, whether I had reached the stage when I could regard myself as semi-skilled, and he affirmed that I could, so I was somewhat encouraged. One aspect of the regime I liked was that forwarders also covered their bindings instead of passing them on to specialist coverers, as was commonly done in fine binderies. Of course, although I was bogged down in that kind of work for what seemed like, at the age of sixteen or seventeen, an interminable period, I was able to watch the experienced journeymen who were engaged on the higher-grade work, and to ask questions. Also, I was fortunate in that I was sent to the old London School of Printing building (fig. 7), in Stamford Street, under the Day Release Scheme, for one day a week. Many firms released their apprentices for only half a day, and some not at all. The purpose of the Scheme was to enable boys to study subjects not covered in their day-to-day training. I recall doing ledger binding, machine pen-ruling, machine binding, paper technology and design. The records I have preserved show that I did quite well with good reports and cash prizes for class examinations [see Appendix B]. When the air raid sirens wailed, mainly in 1941–2, we were ordered into the basement of the school, there to stay

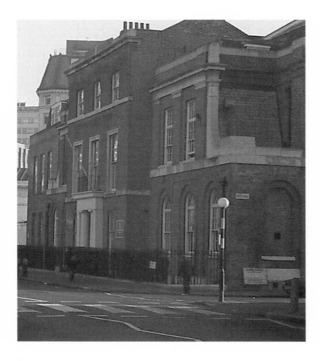

*Fig. 7.* The old London School of Printing building in Stamford Street, London, 1994.

until the all-clear signal sounded. In between trips to the alleged safety of the basement, our studies of ruling, and so on, were enlivened by one of the instructors, J. Esler, a member of the Magic Circle, who performed tricks for us. [A detailed article about the British Museum Bindery which I wrote in 1953 is reprinted at the end of this volume.]

From late 1940 I did a certain amount of fire-watching in the area around the home (fig. 8) of my parents, with whom I lived in Kenton, near Harrow on the Hill, in North-West London. Certain people stayed awake during prearranged periods so that the alarm could be raised if incendiary bombs fell and resulting fires could be tackled promptly with stirrup-pumps. A few bombs did indeed fall in our back garden, missing the house by inches, when my parents and I were in our beds. Our next door neighbour saw what had happened, rushed into our garden and tapped on a window very rapidly with a coin to warn us, but we ignored his efforts, initially, because we thought that the noise was made by a machine gun. Parts of the bombs survived. So, one day I put a fragment on the coal fire in our sitting-room, expecting a modest flare-up, but some of it melted, dribbled out of the grate and set solid, much to my mother's displeasure.

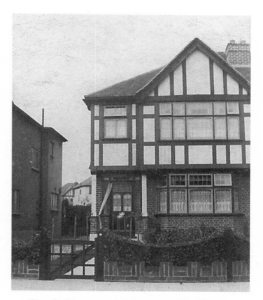

Fig. 8. My parents' home at 22 Kinross Close, Kenton, Middlesex. We moved there from East Dulwich in 1937.

In March 1941, I enrolled in the Home Guard (figs. 9 and 9a), formerly the Local Defence Volunteers, and now known, colloquially, as "Dad's Army". At first, the volunteers were distinguished from other civilians because they wore armbands bearing the legend 'LDV'. Originally, in many cases, armed with only pikes, the ostensible purpose of the force—about two million strong, at its peak—was to repel, or more accurately, impede Hitler's armies should they have the temerity to cross the English Channel. Post-war reassessments have suggested that, more realistically, the principal policy was to boost public morale. Be that as it

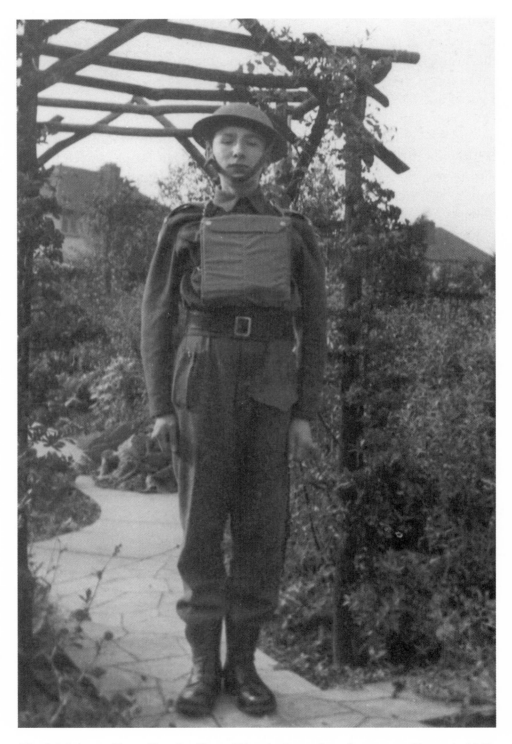

*Fig. 9.* Me in my Home Guard uniform. Taken in the garden of my parents' house in 1942.

*Fig. 9a.*
Home Guard certificate
of service.

I n the years when our Country
was in mortal danger

BERNARD CHESTER MIDDLETON

who served 18 March 1941 – 28 July 1943
gave generously of his time and
powers to make himself ready
for her defence by force of arms
and with his life if need be.

THE  HOME  GUARD

may, we were soon kitted out with khaki uniforms and armed with .303 Lee-Enfield rifles which, for ease of access in a time of crisis, we were allowed to keep at home with five rounds of ammunition. We had service gas masks, hand grenades, Molotov cocktails, and so on. Our platoon, commanded by Lt. Jones, a solicitor, met for training twice a week in the evenings, in the pavilion at a local sports ground, and occasionally at weekends for manoeuvres or firing practice. We did nighttime sentry-duty at the Town Hall and other places of strategic importance. I was a private, but my father, who served in the Home Guard in Holborn near his work in Censorship, was a sergeant. These exertions were very tiring, especially during the worst of the bombing, of course, and it was not unusual to see binders sleeping on benches at lunch time.

When I was called up for service in the Armed Forces in 1943 I did not relish the prospect of footslogging in the Army, so I opted for flying duties in the Royal Air Force. I was not bright enough to be a pilot or navigator, so the alternative was to be a gunner. But, in any case, I failed the medical test for high altitude flying. Perhaps this was fortunate because the mortality rate for gunners was very high, especially for those in the tail. I then put myself down for the Royal Navy, which had the advantage that one was carried around everywhere and in clean conditions—no tramping around in mud.

Despite the distractions of bombing, Home Guard and occasional fire-watching, I had been preparing for the City and Guilds Final Forwarding examination [see Appendix C] and was keen to sit for it, so I

applied for and was granted a three-month deferment of call-up with the help of Ellis Thirkettle, the Principal of the LSP. I hope that the award of a Silver Medal justified that deferment of war service [see Appendix E].

In the Navy I was trained in visual signals in the shore establishment, *HMS Impregnable*, at St. Budeaux, Plymouth, Devon. The training, which was condensed into nine months from the peace-time two-year course, was difficult. Before the start of the actual signal course there was a three-week period during which we learned basic seamanship and were subjected to the usual "square-bashing" (i.e., marching in formation on the parade ground), but with the difference that terms for naval manoeuvres were shouted instead of the usual military ones. At the same time, one was required to learn the Morse code alphabet, numerals and procedure signs, the semaphore positions and the many flags, so that when the course started one could concentrate on their use and work up speed, which was important. Coding had to be learned, and much else such as, I think, fleet manoeuvres. I scraped through everything except the coding examination.

One of the few events of that period which sticks in my mind (apart from an unfortunate episode involving rough cider—I was a non-drinker at the time) occurred one day when I was in a street leading off Plymouth Hoe, a large expanse which affords fine views of the impressive bay. A jeep sped by with gun-toting G.I.'s perched all around it, and heading in the direction of the Hoe. I followed and was rewarded with the sight of General Eisenhower and Field Marshall Montgomery pacing up and down the Hoe in earnest conversation. Perhaps they were thinking about Plymouth's strategic value in the forthcoming invasion of Europe.

Not to be forgotten were rail journeys at that time. When I had long weekend leave from the *Impregnable* I travelled to and from Paddington Station in London. The steam trains were slow, due to wartime problems, and it was often necessary to go via Bristol, so the journey took, I think, about seven hours. The trains were packed with service personnel, and in navigating the side corridor in the old-fashioned, smoke-filled compartment carriages, to get to the toilets, one had to step over both them and their bulky equipment as they lay there to rest or sleep. The lighting was dim and the windows were blacked out for security, so it was difficult to determine where one was during the uncomfortable and seemingly interminable journeys. Of course, the return trip was especially miserable because one was leaving home, family and friends, and returning to naval

discipline and spartan conditions. We were a bleary-eyed and dishevelled lot as we tumbled out of the train in Plymouth at daybreak.

At the end of my training I became an Ordinary Signalman (known colloquially as a 'bunting tosser') and proudly sewed a crossed-flags badge on my right sleeve, and made sure that it was in full view for a photograph. Thereafter I was soon drafted to Londonderry, in Northern Ireland, to join a sloop (an escort vessel of 990 tons) (fig. 10) of the same name. Launched in 1935 with a designed speed of sixteen and a half knots, extra armaments were mounted for wartime service, which necessitated an increase of ballast, so the ship could make no more than eleven knots. The stern was blown off the ship, but that, fortunately, was well before I joined it. From Londonderry we escorted convoys going to and coming from the United States, but the frustrating aspect of it was that we always rendezvoused with the incoming convoy in mid-Atlantic, turned 180° and sailed home. (Another thirty years passed before I was able to set foot in the States.) By this time, early in 1944, the worst of the war at sea, the Battle of the Atlantic, was over, so although we escorted nearly fifty convoys, only two ships were lost. One of them was broken in two after an explosion caused by a mine or torpedo; we did not know which it was, but as the doomed ship was at the rear of the convoy it was more

*Fig. 10.* My drawing of *H.M.S. Londonderry*, executed in August, 1944.

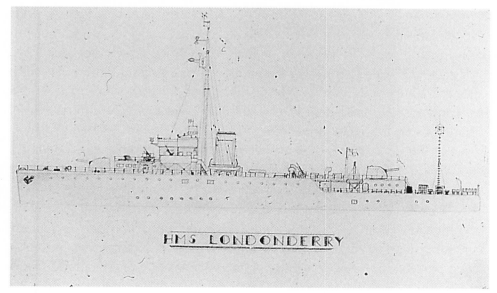

likely to be the latter. Boats were lowered to bring in the dead and survivors and it was my task to go in one of them and establish communication by visual signals with the *Londonderry* which, incidentally, was stationary and therefore vulnerable to attack. My abiding memory of the occasion, apart from one or two nasty sights, is of a great number of electric light bulbs bobbing around—presumably they had formed part of the ship's cargo.

On D-Day [see Appendix F], my ship was involved in a mishap at Southampton; as we steamed along we were on course to collide head-on with an American vessel. As was proper, the *Londonderry* turned to starboard, but the other vessel turned to port for some reason, resulting in an impact which left us with a large hole in our port bow. We sailed to a shipyard for repairs and were cheered on our way by the crews of other ships, who assumed that we had been shelled on the other side of the Channel. It was rather embarrassing. During subsequent months we had a few minor experiences which caused the adrenalin to flow, but nothing much remains in my memory apart from a few hectic moments off the coast of France when the sky was filled with metallic strips intended to confuse our radar, and we were attacked on our port quarter by a plane which, it was thought, had dropped a torpedo. We were not hit and the light was poor, so nothing was certain. Unlike the action in war films, there were many such uncertainties. All in all, we had a very easy ride, so to speak, but in our youthful foolishness we hoped for greater derring-do.

I was not a fully proficient Morse reader, as my Yeoman of Signals would no doubt be happy to testify if he were still alive, but even so, when the transmission was not fast I could read it and carry on a simultaneous conversation when the situation demanded it. When I see a war film I can still read the Morse if it is very slow, or at least, I could until a few years ago, but I have not been tested recently. Flag-hoisting went off tolerably well, but on one unfortunate occasion when I was trying to clip the end of a halyard I let it go and it sped up to the yardarm. As it was I who let it go it was I who was ordered up to retrieve it—an unnerving experience for one who is terrified of heights, and the movement of the ship did nothing to ease my discomforture.

Usually during watchkeeping on the bridge, and not least the middle watch (midnight to four a.m.), there was little to do except try to remember the challenges which were changed daily. If I remember correctly, when vessels appeared, a 3-letter code was flashed, which called for a 3-

letter reply, and this was followed by another 3-letter challenge and another response. An eagerly awaited event was the arrival of extraordinarily thick cocoa which was prepared from a block, was very sustaining and provided a welcome diversion. It was known throughout the service as 'pusser's kye', pusser's being slang for purser's.

In periods of calm, when there was no special activity, there were four of us on the bridge, the officer of the watch, two lookouts and myself. Most of the time I walked up and down the bridge, timing my perambulation so that I was always going downhill as the ship rolled, unless it was pitching and tossing, of course. Perhaps this is why I walk up and down my study when I have to think things out. Signalling in heavy weather was quite difficult. Wind was not too much of a problem on the open bridge because a strip of metal set vertically a few inches away from the sides caused the blast of air to shoot upwards instead of straight over the parapet, but the heavy swell caused communicating ships frequently to disappear during transmission, so that words were lost. The Asdic equipment, used to detect underwater objects, produced pinging sounds which I heard for hundreds of hours, and are very evocative when I hear them now in dramas and documentaries.

Some of the convoys were very large, in some cases covering hundreds of square miles. A signal I was frequently ordered to make to merchantmen, for reasons of security, was "Make less smoke."

It was at this time that my immortal words first appeared in print, though not under my own name. A shipmate who hailed from Buxton, in Derbyshire had received a parcel of comforts from his municipal authority. Although he had been educated at Buxton Grammar School he felt incapable of writing to the Mayor to thank him, so I wrote on his behalf and the letter was published in the local paper.

According to notes I kept at the time, when the end of hostilities was announced on May 7, 1945 the *Londonderry* was escorting a convoy from Milford Haven to Plymouth. The First Lieutenant, who was responsible for the running of the ship, immediately ordered that the brass fittings on the bridge be scraped and polished. They had been painted over since the beginning of hostilities in order, of course, to obviate give-away glinting.

The *Londonderry*'s sister ship, *Wellington*, launched a few months earlier in 1934, has been tied up alongside the Embankment near Waterloo Bridge in London for many years, so I have frequently seen it and been reminded of my brief and unremarkable naval service. About five years

ago I was a luncheon guest aboard the ship, which serves as the Livery Hall of the Honourable Company of Master Mariners, and it was fascinating to see how the vessel has been adapted for its new and very appropriate function. The engines have been removed, and that and adjacent areas have been fitted out to form a spacious Hall where banquets and other events can be held. The area in the bows where the anchor chains used to be, accommodates the Library. Some books needed to be restored, which was the reason for my visit.

When the war in Europe was over, there was talk of my being drafted to a floating dry dock which was being sent to Singapore. As it would have progressed at a stately three or four knots the voyage would have been long and tedious. In the event, I was drafted to the Golden Hind, a transit camp about twenty miles outside Sydney, Australia, which I reached as a passenger aboard the 10,000-ton cruiser *HMS Devonshire*. The month-long voyage was uneventful apart from our having to pick up survivors from a sunken vessel in the eastern Mediterranean. I was in the Sydney area for a few weeks and took the opportunity to see the Blue Mountains and the Jenolan Caves. Then I was sent to Brisbane to join an LST (Landing Ship, Tanks), which was used to take Australian troops back to their home country from Java, Borneo, Malaya and adjacent areas. Having seen pith helmets in films like *The Lives of the Bengal Lancers* I had a romantic feeling about them, and rather enjoyed wearing one on the bridge.

The only potentially serious incident occurred when we were in company with other ships and steaming line astern. The officer of the watch was taken ill and hurriedly went below, without first being relieved by another officer, as he should have been. I was left alone on the bridge. After a short period the ship ahead, which was, I think, usually two cables (400 yards) away, signalled (by hoisting, I believe, three black balls) that it had lost power and was out of control. This concentrated my mind wonderfully and I ordered "hard to starboard" and alerted an officer. End of drama. I cannot claim to have saved the ship because the helmsman would no doubt have acted on his own initiative in time to avoid disaster.

# MY EDUCATION CONTINUES

In 1946 I returned to Britain via Singapore and Trincomalee in Ceylon (now Sri Lanka) aboard the destroyer *HMS Carron*, sister-ship to the *Cavalier* in which Ivor Robinson served. I was demobilized, complete with a suit and trilby hat, and returned to the BM Bindery to complete my apprenticeship, the length of which was cut by a year because of the unusual circumstances. The staff was quite large. As can be gleaned from the appended article [Appendix H] I wrote about the Bindery in 1953, when I suppose it was not much larger than when I worked there a few years previously, there were thirty-four women, most of whom were sewers (in my time they were not allowed to speak to each other while they were working), eleven male paper-menders, two collators, twenty-four forwarders and nine finishers. On the last day of my 'time', and after the customary 'ringing out' when everyone banged press-pins against metallic objects with gusto, I walked into the superintendent's office and asked to be taken on as a journeyman, as was the custom everywhere in those days, and was duly engaged.

In 1949, Howard Nixon[5] took a group of us to see the exhibition of "Modern English and French Bindings from the collection of Major J. R. Abbey" held at the Arts Council's premises in St. James's Square. This was my second opportunity to see work of the finest quality, and on this occasion I was in a somewhat better position to appreciate it. Back at the Bindery, some of the former West End binders pondered how the French had joined the covering and doublues leathers halfway across the thickness of the boards.

For much of the time before and after war service I worked alongside several good ex-West End binders, although, as was not uncommonly the case, they were not very analytical in their thinking, and neither was

I. Always on my left was Dewey, the deputy foreman who had worked at Morrell's in the 1920s and 1930s, and indeed much earlier, and as a result certainly knew how to work slickly. Then, as now, I was keen to practise 'economy of movement', though I did not think of it in those terms, and was therefore always trying to improve myself in that way. In those difficult days it was an important aspect of craftsmanship in trade circles, and it is still of great importance to the survival of the craft[6]. Whenever I could manage it I would start to cover a pile of, say, ten half-leather bindings at the same time as Dewey and try to keep pace with him. In trade fashion, we pasted out a number of covers and drew on them. If there were no raised bands we might paste out and cover eight or ten books at the same time, or perhaps five or six with raised bands. When all the covers had been drawn on, one went back to the first one to turn the leather in and go through to the last, by which time the first one to be turned in was ready for setting of the joints, and so on. It simply was not done to paste out and cover one book at a time: quite apart from the saving of time, it is technically advantageous to work a number of covers concurrently.

As has always been usual in trade binderies, we were required to stand all day, except for seven minutes at 4 p.m. when we sat down beside our benches and imbibed tea. We knew that the period of sedentary relaxation was at an end when the deputy foreman knocked on his bench with a wooden stick. I still stand to do everything except paper-mending, and I regard it as preferable to do so because getting 'over' the work affords greater control, but many non-trade binders prefer to sit for most operations. I work on a lot of books concurrently, and usually with a wide variety of things being done to them, so there is much fetching and carrying which, in any case, makes sitting on a stool scarcely worthwhile.

During 1946 and 1947 I attended Fred Austin's Friday evening Finishing classes at the LSP, and in 1947 gained a City and Guilds First-Class Certificate despite the fact that the Practical part of it required entrants to design and tool a filigree ornament. Believe it or not, I was uncertain what that meant. Shortly after that I taught evening classes there, and often saw Edgar Mansfield (fig. 11) filing his tools into shape for his ground-breaking designs. James Brockman, who used the tools when he produced bindings to Mansfield's designs, has testified that they were beautifully made for their purpose.

My first engagement as an evening class teacher was at an art school in Richmond. such was my nervousness that when I tried to demonstrate (to just one person) the sewing for a pamphlet-style binding, nothing

which could be simpler, I forgot how to do it. So, I hastily explained that the Principal wanted to see me, left the room and stood on the stairs outside while I collected my scattered thoughts.

This was a thoroughly dreary period: bomb sites were everywhere, buildings were run down, wartime rationing was still in force and remained so for quite a few years and, to add to the misery, the winter of 1946–47 was extremely bitter, with icy conditions for weeks on end.

*Fig. 11.* Edgar Mansfield, 1977.

Early in the 1940s, Dora Mary Davies and I often travelled on the same morning and evening Bakerloo Line trains between Kingsbury Station and the West End. She went to Oxford Circus, and I to Euston Square, having changed on to the Metropolitan Line at Baker Street. Early in 1943 we got around to idle chatter, but later that year I was called up and Dora went into the W.R.A.F. for training as a radio operator. Following our demobilization, we again sometimes met as we commuted, perhaps not always coincidentally, and we began to 'walk out', as the old-fashioned expression has it.

Every few weeks, in the late 1940s and 1950s, Dora and I went to the home of Thomas Harrison (fig. 12) and his companion/assistant Florrie Wilson for the evening. Dora and Florrie chatted in the back living room of the little house in Colindeep Lane, Colindale, while Tommy and I were in the crowded front room bindery. He was a man of great experience, having been apprenticed in the 1890s as a finisher at Fazakerley's in Liverpool, one of the finest firms in the country, and worked in some of the best West End binderies, including Zaehnsdorf's, of which he became manager. After his days as a finisher, he taught himself forwarding[7], an aspect of the craft in which he became very analytical, and made some significant

*Fig. 12*. Thomas Harrison in his bindery in Colindale.

contributions such as the 'supported French groove'[8] and 'tape-slotting'[9]. His enthusiasm for the craft was quite remarkable, and he was very articulate, so I just sat and listened until I tottered away late in the evening. One of my very great regrets is that I did not have a tape recorder, rare in those days, with which to keep in permanent form his theories and anecdotes about well-known characters with whom he had dealt. In his later years, when his health was failing, he would often become quite changed and throw off the years as he got under way with some narrative. When I first met him and said that my hobby was archaeology he reacted somewhat negatively and said that he had never needed such a diversion (in fact, he had a considerable interest in and knowledge of freemasonry). Florrie Wilson, who had been with Harrison when he ran Henry T. Wood, a fine bindery in which he had a financial interest and which was forced to merge with Sangorski's in the late 1930s, was a very expert and swift sewer and headbander: her like no longer exists. Harrison died in 1955 at the age of 78.

In 1949 I heard that Roger Powell, the part-time Tutor in Bookbinding at the Royal College of Art, was looking for a Craftsman-Demonstrator, a humble position which in less exalted institutions might be designated Technical Assistant. It was a new position in a fundamentally reorganized College regime, under Robin Darwin. Previously, graduates had become teachers, but now the plan was to fit them for positions in industry. To this end, the Tutors were part-timers who were distinguished and still active in their various fields, rather than full-time and out of touch. One such was Ruari McLean, Tutor in Typography. The plan has succeeded in full measure. Anyway, I applied, was duly interviewed by

Powell and by Professor Richard Guyatt, the head of Graphic Design, and was accepted. Although it was a humble position it opened up a new and exciting world for me.

As I have already said, most of the men with whom I had worked were excellent trade craftsmen, but they were blinkered, and rejected out of hand unconventional methods and techniques (as did I) and their outside interests were very limited. Very few would consider reading books and attending lectures for the purpose of increasing their understanding of their work. At the RCA I was surrounded not only by first-class teachers, but also by students who were the *crème de la crème* of the art school system, and interesting visitors. I was much impressed and even took to wearing corduroy trousers. My newly acquired awareness of calligraphy caused me completely to change my handwriting to something vaguely resembling italic.

Roger Powell was a cultured man and very well spoken; a new acquaintance, somewhat taken aback, exclaimed "He's a gentleman!" He came to the College two days a week, his approach along the corridor being heralded by his vocalization of tunes from Gilbert and Sullivan operettas in which he performed—very competently, I gather—at Petersfield, near his home at Froxfield, in Hampshire. Two other circumstances I recall from that period are that he kept a stock of home-produced honey in a cupboard for anyone who cared to purchase some, and that I never saw him handle a tool or demonstrate a technique. Admittedly, demonstration was one of my responsibilities, but even so it seemed odd that he never felt the urge to perform. He remarked to me that when people suggested techniques which were new to him, his initial reactions tended to be negative, but that he would always try them out, and certainly his career amply demonstrated that he did have a very open mind.[10]

Apart from helping the students, of whom there were few, and occasional outsiders who came in for short courses, my duties involved keeping the bindery in order and doing whatever was required by people in other departments. One such (unpopular) task was to bind glossy magazines for the School of Fashion. The Festival of Britain in 1951 created a good deal of activity because the College was responsible for the design of much if not of all that went into the Lion and Unicorn Pavilion on the South Bank in London. I had to make a large display of leather-covered dummy backs lettered with the titles of the classics of British literature. A major task for the bindery involved the production of large Visitors ' Books for V.I.P.s, for major centres throughout the country. I had to bind

the books very quickly, and Peter Waters, who was then a student, designed and tooled them with equal urgency. Such was the frantic haste that at least one of the books was wrapped and parcelled in a taxi as we went to a railway station for its despatch.

I saw a good deal of Sheila Salt, who was then studying calligraphy under Dorothy Mahoney. She and Peter, both star students, were engaged in 1951, married two years later, and formed a remarkable partnership of complementary talents. Peter and Sheila were guests when Dora and I married in 1951, and we attended their nuptials. Towards the end of my stint at the College, the now celebrated Philip Smith became a student. For about two years I had been in the company of well-educated, creative people who were engaged in a variety of disciplines, and who had flexible minds which were receptive to new ideas, and most had a broader range of skills than trade men, whether it was binding, silversmithing, or any other activity. I am grateful that, previously, I had been able to work with quick, efficient trade men for several, but not too many years, because this has been important economically, and that I was then exposed at an early stage in my career to the influence of those with a very different outlook on life. It was also great fun and good experience to go on trips with Powell and the students to Barcham Green's paper mill at Maidstone, Kent, to Band's, the vellum-maker's equally 'Dickensian' premises at Brentford, and to G. W. Russell's tannery at Hitchin. There was the occasion when Cambridge colleges mounted exhibitions of antiquarian bindings, and we all spent a pleasant and instructive day going from one to another. For the purposes of reference I lugged around a copy of Hobson's heavy tome, *Bindings in Cambridge Libraries* (1929).

Early in 1950 I sent the typescript of the first article about binding I wrote to *Paper & Print*, the subject of which was 'Scale in Bookbinding' [see Appendix G]. I heard nothing for some weeks, and then the editor sent me an invitation to contribute a series of articles. I naturally assumed that this initiative had stemmed from the unsolicited piece I had proffered, but the editor knew nothing of it. There was some confusion, and it was a curious coincidence. My re-offered article was duly published in the Summer issue, and was followed by several more for the same periodical. I enjoyed writing, and subsequently contributed many pieces, including a few leaders, to the quaintly-titled *British & Colonial Printer.*

# ZAEHNSDORF'S

In 1951, with the aid of Edgar Mansfield's sponsorship, I was elected a Fellow of the Royal Society of Arts (1754) (fig. 13). Late in the same year, through the good offices of Thomas Harrison and Ellic Howe, the bookbinding and printing trades historian, I was appointed manager of Zaehnsdorf Ltd.[11], an internationally known firm[12] of bookbinders, established in the early 1840s[13]. At that time, the firm was a subsidiary of Hatchards, the booksellers, of which Ellic Howe was a director. In their heyday, in the late nineteenth century, Zaehnsdorf's employed about one hundred people, but in my time there were about twenty-five. The bindery was still accommodated in the building constructed for it in 1890, at Cambridge Circus (fig. 14), in the heart of London. The bindery moved elsewhere many years ago, but the building still stands and "JZ" can still be seen in the tessellated area by the door of the original showroom on the ground floor. Above the door is a stone bas relief panel depicting a sewer sitting at a sewing frame. Communication between floors was by voice-pipe, which was familiar to me from my time on the bridge of the *Londonderry*. Indeed, much of the bindery retained the atmosphere of its Victorian origins, which suited me very well because I am a reactionary, or to put it more bluntly, as some have, I am a stick-in-the-mud. Originally, Zaehnsdorf's occupied all five floors, but by the 1940s they had withdrawn to the upper three. The row of huge old standing-presses, which may well have come from the bindery's previous location[14], was there and in use. In my office the clerk's high desk was still used, and I worked at the old roll-top desk.

This was a difficult period for me because at the age of twenty-eight I was too young and inexperienced to deal confidently with the works manager and others who had been employed there for decades (in one

# ROYAL SOCIETY
# FOR THE ENCOURAGEMENT OF ARTS
# MANUFACTURES & COMMERCE
# LONDON

Founded 1754           Incorporated 1847

*President: H.R.H. The Princess Elizabeth, Duchess of Edinburgh, C.I.*

*11th June 1951*

Sir,

    *I have the honour to inform you that you were this day elected a Fellow of the Royal Society for the Encouragement of Arts, Manufactures and Commerce.*

        *I am, Sir,*

           *Your obedient Servant,*

*Secretary*

*Bernard Chester Middleton, Esq.*

**Fig. 13.** Royal Society of Arts Fellowship certificate.

case for about fifty years) and on higher grades of fine bindings than those to which I was accustomed. Another problem for me was that a number of experienced people had recently died or retired, necessitating the training of young and not-so-young craftsmen from elsewhere—an expensive process. At this time, when I was also teaching evening classes at the London School of Printing, I invited William Bull, a promising student who was employed by a ledger and letterpress bindery, to join me at Zaehnsdorf's, which he did. The arrangement was successful, but the move got me into trouble with trade union officials who accused me of ". . . using my privileged position to poach labour." However, despite the worries, there were compensations in the variety, quality and interest of the work going through the bindery.

The amount of work that was available in the post-war period was immense, and included Rolls of Honour; conventional fine bindings on standard works for what used to be called the 'carriage trade' and sold by Hatchards, Asprey's, Sotheran's and from our own showroom; the binding of lectern Bibles; the making of dummy backs for stage sets and doors in private houses; restoration for the Library of the Guildhall in the City of London, and much else. Not all the dummy backs we made were new. Old leather-covered books were in very plentiful supply, so we sometimes

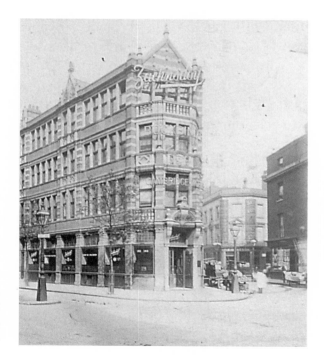

*Fig. 14.*
The Zaehnsdorf building at
144 Shaftesbury Avenue,
as it was in the 1890s.

29

detached the spines in a guillotine for subsequent mounting. Even though they were probably odd volumes from sets, I still squirm when I think about it. It was interesting to deal with a distinguished clientele which included people in the entertainment industry, politics, the armed forces, the church, and sundry authors, though Sangorski's certainly had the edge in this respect. One diverting episode had a farcical element. A film company's Art Director called in and asked us to provide bookbinding equipment for a set in a film called, I think, "Intimate Relations." My wife and I were invited to the studios to watch the scene being shot. We were given two canvas-backed chairs without which no self-respecting studio is complete; unfortunately, Dora sat down in hers with such vigour that both it and she went over backwards, and she found herself with her legs in the air. By great good fortune, the clatter did not happen while the camera was rolling, so we did not incur the wrath of the director.

The most prestigious commission during this period was for the rebinding of the *Book of Kells*, which went to Roger Powell. Sir Thomas Moore, M.P[15], the chairman of Hatchards, our parent company, heard about it and instructed me to enter a rival bid, which I did. Thank goodness it was not accepted, because otherwise that priceless treasure could well have ended up in a West End binding in the manner of the *Domesday Book*, rebound by Riviere in the mid-nineteenth century, and responsibility for the disaster would have been mine. Powell's unfamiliar and unconventional solutions to the problems posed have been widely lauded.

Our rivals, Sangorski & Sutcliffe, were invited to bind the Coronation Bible for use in Westminster Abbey on the great occasion, an obviously important, 'high profile' commission. All I could do to mark the event was to bind books about royalty (rather less sensational than those in circulation today) in purple goatskin with gold-tooling in appropriately regal style, and with the additional delight of a fore-edge painting of a Coronation Procession which came into view when the edge was fanned out. It sounds somewhat naff, but I think they sold quite well, and that is what mattered at the time. A notable commission which brought us some publicity was for the restoration of the Eisenhower Family Bible.

The biggest project during my brief time at Zaehnsdorf's was our participation in the binding, in 1952, of the *Royal Philatelic Collection*, which I described in an article written soon afterwards, as the most notable and interesting book-production enterprise of the century up to that time, of course. The quality of the printing, which was done by means of the expensive collotype process, was superb. In addition to Zaehnsdorf,

seven other binderies were involved, including Bayntun and W. H. Smith the co-ordinating bindery. Thomas Harrison was brought in as a technical consultant, and we all had many meetings of the proprietors and managers at Smith's former bindery, now demolished, at the southern end of Lambeth Bridge. Due to Harrison's influence, a great deal of thought went into the structure of the binding, which had to overcome problems with the paper and the size of the book—a substantial quarto. The reinforced endpapers and hollow backs were complicated and the bindings had the first major use of the 'supported French groove'. As previously indicated, binderies were experiencing boom conditions and, therefore, there was a shortage of skilled labour. For this reason, only the top edges were gilt (this was a few years before the mechanization of edge-gilding) and tooling was kept to a minimum.

One of my 'new broom' enterprises was the introduction of a more modern style of gold-tooled decoration of bindings (fig. 15) displayed in our showroom and that of Hatchards, in Piccadilly. The designs, based on Edgar Mansfield's suggestions, were, in my view, restrained and elegant and in no way outrageous, but the middle- and upper-class and aristocratic book buyers did not fall upon them with open chequebooks. Even today, nearly fifty years later, there is no hint of an advance from the old favourites on the books, whether they be old or new publications, displayed on booksellers' shelves in London. I suppose the failure of the unfamiliar new designs to catch on was due in large measure to the conservatism of the dealers' clientele. I can, to some extent, understand the reluctance to be more adventurous because bought as furniture, as many such bindings are, the richness of traditional full gilt tooling does have a strong appeal, certainly for me.

Hatchards was at that time connected with a well-known financier who had been jailed before the Second World War for fraud. I was somewhat amused when a director, one of the financier's convicted associates, remarked to me that the thing he liked about me was that I was honest. Soon afterwards, there was a threat of financial trouble and Ellic Howe, a director, and certainly unimplicated, rapidly dissociated himself from the company, leaving me without moral support.

When I was appointed manager I reserved the right to use the facilities for my own work on Saturdays, one reason for this being that I was anxious not to lose my skills, such as they were. After about two years, in 1953, Dora and I decided that the time had come to paddle our own canoe, so to speak. It was not an easy decision because although my position had

# Controversial Thoughts on the Decoration of Fine Bindings

## By Bernard C. Middleton, FRSA

I have been moved to write this article because during the past few weeks my activities in the field of book cover design have, in some quarters, been the subject of comment and criticism. The designs in question have been executed on bindings now on sale to the public at Hatchards Ltd, Piccadilly, the work having been carried out by Zaehnsdorf Ltd and W. T. Morrell & Co Ltd.

Actually, the conflicting opinions are not just over my particular efforts, but over the general principle that the design of trade fine bindings should be brought up to date, and whether it is the moral duty of the binder to lead the public to better things or merely satisfy the customers' demands, however bad they may be.

It so happens that Zaehnsdorf Ltd are the first of this country's trade fine binders to modernise their ordinary 'stock' work (that is, bindings produced for the bookseller's shelves), and for this reason the proverbial coals have fallen on my head!

### GOOD VERBAL DEBATE NEEDED

It is my hope that some of the many people who obviously hold very strong views on this subject will put them into print in these columns for the benefit of us all. There is nothing like a good verbal debate for the broadening of one's outlook, but the medium of the *B&CP* has the advantage that only one person at a time takes the floor, so to speak.

For some time now I have been verbally advocating a fresher approach to the decoration of the more ordinary fine bindings—those that can be taken from the bookseller's shelf, not specially commissioned ones. Some of my words have fallen on fertile ground, but most of them seem to have come to rest on particularly stony and most unfertile terrain.

My view is that, from the point of view of design, too much trade bookbinding is dead—dead because it is out of date and lacking in vitality. I like many of the bindings produced in the West End at the present time; I like them for what they are, but they are something that rightly belongs to the past—they are out-moded and 'done to death.'

### WHY HAVE BINDERS LAGGED BEHIND?

Practically everyone in the trade is producing bindings that would have been perfectly in place thirty or forty years ago—why? Again, why have binders allowed their art to lag behind all the other domestic arts in modernisation? The answer is easily understandable in the case of the older men in the trade, but it is not so easy to understand the conservatism and apathy of the younger men.

I must emphasise that I have no or few objections to most of the old floral designs beyond the fact that they are out of their period. Two- and three-line panels are regarded by some as the aristocrats of bookbinding, and I agree that they are very elegant, but they, too, have had their time.

It will be taken for granted, I hope, that I do not advocate very modern decoration for very old books, but rather that designs appropriate to the period of the book should be given a modern interpretation. By so doing it is possible to link the period of the book and its binding without incongruity.

I am, and always have been, opposed to change merely for its own sake, but the fact is that human outlook on design, and life in general, is constantly changing; this is reflected in the design of everything from egg cups to concert halls. The aim in industrial design during the last thirty years or so has been to eliminate superficial excrescences and to create wares which derive their beauty from good proportions and clean curves and lines and the undisguised material from which the article is made. Many objects which are properly designed for their purpose already have sufficient beauty and require no extra embellishment. In the case of bindings this is not always true, but very often it is. A properly bound book is one of the most functional things available for everyday purchase—and one of the most beautiful.

In order to achieve the desired effect I prefer most bindings to have no raised bands; then we have the lovely gentle curve of the boards sloping more steeply at the edges contrasting with the greater but not excessive round of the fore-edge and spine. The thickness of the boards, the slight rounding of the corners, the squares, the 'round' of the book and the smooth unbroken surface of the spine are a delight to the eye.

This composite effect, beautiful though it is, can usually be enhanced by decoration in similar vein. The result is something that can take its place without incongruity in any modern home. What a pity it is that the effect is so often lost because lumps of hardware and semi-precious stones are plastered on to the surface.

When the book is off the shelf I think that raised bands rather spoil the curve from the boards over the spine. However, they do help to break up a long, awkward area and provide their own form of decoration; in addition, as most bindings spend practically all their lives reposing on bookshelves, I suppose that their effect in that position should be our first consideration. Most raised bands nowadays are, of course, false ones, and apart from the consideration of their aesthetic value there are arguments concerning the ethical point of view which could be quoted, but I do not think that we need become involved in those at the present time.

It will not have escaped some readers' notice that although I have said that I prefer bindings to have no raised bands there are, even so, two on the book illustrating this article. They are there mainly because I am told by people with

*Binding by Zaehnsdorf Limited (Finisher: Frederick J. Greenhill) in full royal-blue morocco with blind and gold lines.*

more experience than myself in dealing with the book-buying public that they are the characteristic by which the layman distinguishes a hand-bound book from a mass- or semi mass-produced one, and partly because I do believe that they preserve the remainder of the spine from a few abrasions.

### TRADITIONAL DECORATION

However, to get back to the main theme, my point is that all other domestic wares can be obtained in clean, contemporary designs, but where, in the first-class bookbinding trade, can equally modern bindings be obtained? The answer is 'practically nowhere,' and if that is not cause for depression I do not know what is.

It is admitted that there are many people who will not want to purchase bindings with anything but traditional decoration; they belong mostly to the older generation who have been reared in the atmosphere of heavy

*continued on page 620*

*Fig. 15.* Article in The *British & Colonial Printer*, 16 May 1952 with illustration of new-style binding.

been anything but a sinecure, it had been a wonderful learning experience for a young man, not just about the craft, but also about related business matters, and I had enjoyed meeting distinguished people. Another, not unimportant factor, was that we had only modest available capital, and, on the domestic front, we were living in the upper half of my parents' house without the prospect of having our own home. The emphasis in our business was to be on the restoration of books, for the two good reasons that it would be easier to compete with established binderies whose standards in this field were not wonderfully high, and because I had a great interest in the past. I wonder how we survived the early years because I now know that I had very little knowledge of, or skill in, restoration, and I possessed very little of the paraphernalia on which its success depends and the accumulation of which takes many years. I do not recall that my lack of expertise and resources caused me undue concern, so it must have been a case of 'ignorance is bliss.'

From the summer of 1947 I had been involved, in the most humble way, in properly conducted excavations on sites of the Roman period. My first experience was in Southwark, south of London Bridge, in evening excavations directed by Kathleen Kenyon (daughter of Sir Frederick Kenyon, formerly Director of the British Museum). It was a bomb site and the local authority planned to build flats on it, so our work had to be expedited. The trenches, which went down about twenty feet below street level (fig. 16), yielded artefacts from all periods. The area was the site of the Marshalsea Prison, demolished in 1849, and mentioned in *Little Dorrit*. In the same year, during my summer holiday, I helped with the excavation of a fine Roman villa at Low Ham, in Somerset, and then from 1949 Dora and I spent our summer weekends working on a major villa near Lullingstone Castle, in Kent. I concentrated on the study of glass and two of my reports on these artefacts were published in *Archaeologia Cantiana,* the Transactions of the Kent Archaeological Society. In 1947 I became a member of the Institute of Archaeology[16] then housed in St. John's Lodge, a fine early nineteenth-century structure on the Inner Circle, Regent's Park. There I spent a great many winter Saturday mornings in the extensive cellars washing finds from 'digs' and helping to piece together fragmented wall paintings from Lullingstone. Around this time, Roman glass found on the royal estate at Sandringham was sent to me, and I duly submitted a report on it. The fragments were contained in many boxes which were stored under our bed in the furnished rooms we rented in the very early years of marriage. Archaeology was important to me, but it had to be abandoned when we started our own business in 1953.

JOHN BULL August 30 1947

*Are you happy in your leisure?*

# THEY DIG FOR HISTORY

Meet the amateur archaeologists. John Bull, reporting on
people with hobbies, tells the story of enthusiasts who
dig—not to grow roses or marrows—but to unearth history

CROSS OVER LONDON BRIDGE from the City any fine Tuesday or Friday evening and carry on down Borough High Street to Newcomen Street. Turn off past the "King's Arms" on the right—suddenly there is a wide clearing in Southwark's bricks and mortar.

The jagged walls are grass-softened now, the gaping basements so sedate and tidy they seem part of the natural scenery rather than relics of the blitz. The place is a paradise for the local kids. Little groups of them play happily about among the broken walls.

But wander around a bit and maybe you'll begin to be aware of something a little odd about one particular gang grubbing about in a bombed basement.

These "children" seem very large. And remarkably quiet. And some of them seem to have come in motor cars Look again . . . and you see that they're full-grown men and women.

Two girls crouch at the bottom of a trench, probing about with pointed trowels. A man hauls up a bucket full of soil on the end of a rope. A woman in a yellow jumper squats writing in a notebook. And, at the far end of the site, there's a chap with a folding rule, and another jotting things down on a scrap of paper.

Each is utterly engrossed in his or her job.

And digging up history *is* a serious business. For that is what they are doing on this very ordinary bombed site in this very ordinary street. In office hours these men and women are teachers and clerks and engineers and architects; but in the evenings they are archaeologists, digging up our past, uncovering the intimate lives of our forebears and getting as much of a thrill from turning up a few bits of Roman pottery as Mr. Howard Carter ever got from opening King Tut's tomb.

The woman in the yellow jumper seems to be running the show. Let's have a word with her.

She's a professional, Miss Taylor from the Institute of Archaeology in Regent's Park. She picks up the roll of paper lying on the earth beside her, a map of Southwark studded with little black oblongs. Each oblong represents a bombed site. Across the streets and the oblongs run parallel dotted lines which *could* be Roman roads.

## Non-stop Until Nightfall

The man with the folding rule comes over from the end trench to consult Miss Taylor, the professional, P. L. Styles, of Temple Sheen Road, East Sheen, is, in office hours, a surveyor with the Middlesex County Council.

"I expect we'll be here till it goes dark about nine tonight," says Styles. "Don't quite know why—but I find it's pretty hard work, too. I'm usually quite whacked by the time I get home, aren't you, Bernard?"

Bernard is twenty-three years old Bernard Middleton, of Kinross Close, Kenton, near Harrow, a book-binder at the British Museum, not long out of the Navy, and for him archaeology is one of the new-found pleasures of peace. "My enthusiasm is greater than my knowledge," he says.

The centre trench is now down to the natural

sub-soil, ten feet below the surface—twenty if you count from the street level. And two-thirds of the way down the wall of the trench you can see a faint red mottled layer running straight across the earth face like strawberry jam in a chocolate cake. For Styles and Middleton that red layer was quite something.

"See, it had a camber on it," says Middleton. "And you can just make out the wood-lined ditch here," says Styles, jumping into the trench and tracing lines on the soil of the end wall with a trowel.

It seems the red layer may be a Roman road—connecting, perhaps, with the famous Watling Street.

In the fullness of time a few more details may be sketched into the picture of the London the Romans knew.

"I know a lot of people think all Roman roads were made from great chunks of stone," says Middleton. "But there were a lot of metalled roads as well, made from iron slag concrete."

## Clues in the Tray

A girl climbed out of the cross trench carrying a shallow iron tray. It bore the product of an hour's painstaking sifting and probing of the soil.

The stuff in the tray was the sort of nondescript collection that might be found at the back of anybody's garden. No coins, no bronze vases, not a single arrowhead. . . .

Yet to the skilled archaeologist many of these bits of tile and glass and pot and bone would yield a story, filling in another fragment in this slow-building jigsaw of Roman Southwark, just as this jigsaw itself would, completed, fill in another tiny hole in the larger jigsaw of Roman Britain.

There were lots of bits of red tile in the tray and a fragment of stoneware ("probably early seventeenth century," pronounced Miss Taylor). There were bits of oyster shell ("The Romans were hot on oyster shells. We're always finding them in their rubbish heaps"). There was a twisted bit of bone ("We always keep the bone for examination"), and a bit of an earthenware plate, brown with white streaks ("two-coloured drag, popular in the sixteenth and seventeenth centuries").

And there were two broken bits of clay pipes. The diggers were well used to clay pipes. They are turning up all the time. For the soil files away its history impartially. And this was the site of Marshalsea Prison, the old Admiralty jail abolished in 1849 and referred to in *Little Dorrit*.

As the work goes on the clues from the trays are packed away with their labels in brown paper bags. At the end of the "dig" they'll go over to the Institute of Archaeology. Then, Saturdays, some of the amateurs go over there and wash their week's finds before the Institute's experts go to work on them, building up the picture.

You need plenty of patience in this game—the scientific approach, in fact. For a find like the Mildenhall Treasure, which was unearthed in Suffolk in 1942, doesn't come to light every day—and even when it does, it's ten to one some ploughman or builder's labourer turns it up.

Digging may go on for a day, for a week, with

every bit of soil carefully sifted and every fragment of bone or pot scrutinized, and, at the end, nothing of much interest may be found. So far, on this Newcomen Street "dig" a few coins and one or two nice bits of Samian ware have turned up. "But I've not had the luck to be in on any of the finds," said Middleton. Except the French franc we found stuck in the side of a trench . . . that was the kids, of course."

The local kids, naturally, find the archaeologists an excellent addition to bombed site sports. At first they made all sorts of irregular contributions to the proceedings, but when that began to pall, some of them took an interest in playing the game according to the rules. They've turned in some quite useful finds. But this, and other, bombed sites are scheduled for building and the L.C.C. Housing Department waits for no man—not even Julius Caesar. So all through August the "dig" has been speeded up.

## "Digs" Are Open to All

Anybody who's interested is welcome to go along and ply a curious trowel. The Institute of Archaeology keeps a register of people who would like to dig and for a fee of a shilling or so keeps them posted with news of all the "digs" which are going on in their area. At present something like thirty excavations are in progress in various parts of the country.

Styles says it was a book in the public library that started him off—Atkinson's *Field Work in Archaeology*. He was so interested that he wrote to Atkinson at Oxford to ask how he could get in on it. Atkinson referred him to the London Institute of Archaeology—and so here he was.

"I feel it's a hobby where you're doing something useful and well, sort of, in however small a way, adding to the fund of human knowledge."

Middleton agrees: "People often say to me: 'What's the use of it?' I tell them that lots of people are interested in history, in the past. Archaeologists provide the evidence for history. And, you know, when you actually find and handle bits of implements and things people used centuries ago . . . well, it's so different from just reading about it. The penny drops, so to speak."

HENRY FIRTH

Is this a find for Bernard Middleton, ex-Naval man? For him "historical" spadework adds zest to civvy street

*Fig. 16.* Article in *John Bull* magazine, 30 August 1947 with illustration
of myself excavating in a trench.

# A BUSINESS OF OUR OWN

W e set up in two rooms which comprised the top floor of a house built in 1734-35 at 63 Broadwick Street, Soho (fig. 17), just around the corner from Sangorski's in Poland Street. The house still had virtually all of its original features, including the wood panelling all down the stairwell, and few modern amenities. The street, called Broad Street until 1936, came to public attention in 1854 when Dr. John Snow drew the conclusion that cholera, of which there was a very bad epidemic in the area at the time, was water-borne, and prudently caused the handle of the street pump to be chained up. The inhabitants of only twelve of the forty-nine houses escaped death. The pump has gone, but a red kerbstone marks its original position. The binders J. Wickwar, of Poland Street, and John Wright, of nearby Noel Street, and a number of their employees died of cholera in the same week in September of 1854.

In the 1950s it was a pleasant, relaxed area, about fifty yards from Carnaby Street which at that time was just a shabby, little-known backwater. (There was no hint that it would, before long, become internationally famous as a centre for pop fashion.) Soho, a district of about half a square mile, composed of narrow streets and courtyards, is noted for its centuries-old racial mix and bohemian lifestyle. Around our street there was an almost village atmosphere, with Welsh dairies and modest craft-based businesses, many connected with the clothes industry. On the other side of the road, and all around, Jewish tailors could be seen at work, sitting crossed-legged on tables for long hours. Broadwick Street was still illuminated by gas-lamps which were operated by a man who came along with a long pole.

*Fig. 17.* No 63 Broadwick Street, on the right.

The only available water in the house was cold and was to be found at a tiny triangular sink on a half-landing halfway down the stairs, not the ideal arrangement when one was washing paper, crockery, or whatever. The toilet was located in the small backyard, and its use was somewhat hazardous because the Maltese film extra who lived on the floor beneath us was wont to throw noxious liquids—I will spare readers the precise details of their nature—out of the window in the time-honoured Mediterranean fashion. The place was not easy to work in because, for instance, the floors were so shaky I was unable to install a board-cutter. This privation necessitated my using a pair of 34-inch long shears, one arm (21 inches long) of which was held in the lying press (fig. 18), to trim boards roughly to size, as was the practice nearly two hundred years ago, and then cut them to exact size with a plough in the cutting-press. It is an expensive process when one is box-making, but the result is excellent, so I still plough my boards for designed bindings. The floor sloped so much that I had to insert a thick wedge under the front of a filing cabinet in which I stored old paper, so that the drawers would not slide open involuntarily. Another frustration arose from the presence of the Maltese film extra who lived below me; I had to wait for him to go out so that I could get on with the backing of books in the lying-press (figs. 18a and 18b),

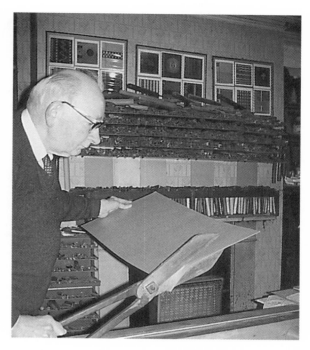

*Fig. 18.*Using board-shears in 1999—the first time since 1960.

which involved heavy thumping with a hammer. Apart from that, I walked around ancient and creaky floorboards as noiselessly as I could because, unfortunately, when he was not filming, he filled in with night work as a guard, so of course he slept during the day. Because he did not have a tele-phone, I passed on messages from Central Casting, which sounds straight-forward, but he was very loquacious, so much time was wasted. One of the hazards in the house was the total lack of lighting on the staircase and in the hallway leading from the front door. Many people negotiated the ascent and descent very gingerly, step by step, in complete darkness. Only comparatively recently have the legal ramifications resulting from injury dawned on me. But at that time people were must less litigious, and nobody warned me. After a time we installed a light outside our door on the top floor, which helped in the immediate vicinity.

There were some amusing diversions from our problems. Directly opposite our place, on the other side of the street, was the house in which William Blake was born in 1757; a lady of pleasure practised her profes-sion on the top floor with less than adequate, semi-transparent curtains over the windows—an oversight which afforded us welcome distractions from the tasks in hand. Another, rather elderly professional lady enter-tained her clients in the house next door at No. 65. Unfortunately, one of

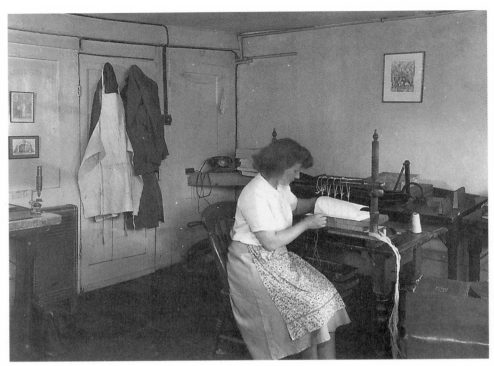

*Fig. 18a (above).* View of the front room at 63 Broadwick Street, with Dora and myself.
*Fig. 18b (below).* Another view of the front room at 63 Broadwick Street.

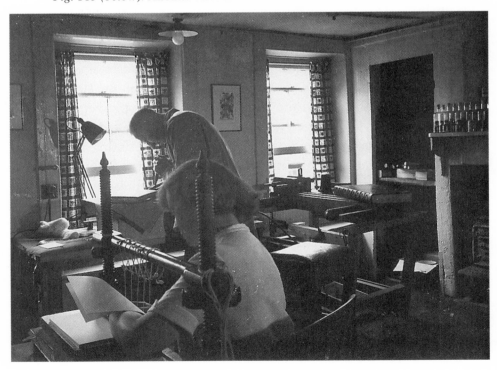

them died while being so entertained and, according to local legend, while he was departing feet first, another was on the way in, but I cannot vouch for the veracity of this tale. Regrettably, all three houses have now been demolished. Dora and I hardly ever walked along Broadwick Street after we moved away, but one evening, about twenty-five years ago, we happened to pass No. 63 while it was in the process of being demolished and were quite misty-eyed about the old place and our years there.

At the time of our marriage in 1951 Dora had been training to become head bookkeeper at Parke-Davis, the pharmaceutical company, just around the corner from Broadwick Street as it happened. Her expertise relieved me of worry in that department and, indeed, her detailed analysis of expenses and so on, reduced accounting fees. Having given up her full-time job she was able to come into the bindery part-time to do the sewing. She was very good at concocting lunches on our Baby Belling gas-stove in the back room, an inconvenient feature of which was a steeply sloping ceiling, so characteristic of eighteenth-century garrets. In the summer, we kept butter and other items cool in a special container over which we had to pour water for evaporation.

In one way it was easier for me to start on my own as a restorer than it is for those who start now, inasmuch as it was possible to walk into N.J. Hill's premises in Chalk Farm, London, and buy second-hand finishing tools off the shelf at comparatively modest expense. Without them one cannot properly restore the more sophisticated antiquarian tooled bindings. Small tools cost 2/6d (12½p) each, and large ones 3/6d (17½p). Unfortunately, I did not have the funds to buy as many as I needed. Today, such tools are not so readily available and at auction they fetch £15 to £20 each, and sometimes much more, even when they are in poor condition. On the other hand, there was a much more restricted range of new materials (such as convincing old-style marbled papers which are now excellent and widely available), and few were of archival quality—newsprint was common. It is a matter of very considerable regret for me that until about 1984, when tanning methods were revised following several years of scientific research, I used leather which had a comparatively short life-expectancy. I know from personal experience that some of the calfskin I used in the 1950s perished some years ago.

I had anticipated that my first work would come from Lambeth Palace Library which had been the recipient of a very substantial grant from the Pilgrim Trust. Some of the work had already been done by

Zaehnsdorf's and others. Just at the wrong time for me, the Librarian went away for two weeks, so I was forced to occupy myself with tasks of a somewhat less demanding nature. These included re-endpapering broken-down books for the dealer Harold Mortlake in Cecil Court, Charing Cross Road, for a few pence each, for which remuneration I also had to collect and deliver the books.

I also pared tawed leather joints for Marshall's bindery, at Banstead, which specialized in the production of large *Books of Remembrance* for crematoria. With the advice of Thomas Harrison, they went to very great lengths to ensure durability, including making their own boards with hand-made paper. I believe that some tawed-leather thongs had vellum cores[17].

The Lambeth Palace Library project was less than satisfactory, to say the least of it, because the Librarian's adviser instructed all binders to re-endpaper repaired books; this was bad enough because in the great majority of cases it was not necessary, but we compounded the felony by using very unsuitable new paper. It was wonderful for me and the others involved because it was possible to build up a good stock of old flyleaves, many of which, I am embarrassed to relate, bore press-marks. As I recall, too little was done about preservation of original spines, unless they were gold-tooled. For these reasons, and my own lack of experience and spe-cialized skills at that time, I would hate to be confronted with any of the books which passed through my hands. A dispiriting thought which now occurs to me is that, as I remember, we were required to sign the repaired bindings.

An embarrassing incident happened in the mid-1950s. I had recapped a folio volume which was in elaborately gold-tooled red goatskin and I delivered it with other books to Lambeth Palace. As I left Morton's Tower, the gate-house, a library assistant chased after me to point out that when she opened the book it had broken into two parts and was held together just by the new caps. Oh dear! Later, I did some work for Westminster Abbey Library, and I think that I may have performed rather better, though I would prefer not to investigate for confirmation. When I see dreadful pre-sent-day 'restoration' I do try to remember my own early (and not so early) failings, and as a result moderate my criticisms. It is very easy for the elderly to forget their own early circumstances.

Early on, I started to produce antique-style bindings for books which had lost their original covers. I had few resources, so they were simple 'common calf' or half-calf bindings done with all the verisimilitude I could

manage so that they would stand inconspicuously among original bindings. It has been suggested that I was the first in Britain actually to 'age' old-style bindings by staining endpapers and marbled paper sides in strategic areas, and so on. This had not occurred to me and I do not know if it is true, though later on I did introduce the use of leather scrapings as a surface treatment in restoration, and the use of straight-grain pallets for a purpose for which they were not originally intended[18]. Old style bindings were produced in very large numbers in the nineteenth century, but they were Victorianized, which is to say that they were too precise, and there was no close attention to period detail and condition. The same can be said of books bound during the first half of this century. My aim was to go further than this, so in addition to localized paper staining and dirtying, I aged gold tooling, slightly rounded the corners of new flyleaves to match those of the text leaves, dampened flyleaves so that they would take up corrugations in the text-block and look original, knocked over the corners of the boards, and so on.

This policy has attracted opprobrium from some conservators whose point of view I can understand, but the great majority of the people with whom I deal, collectors and dealers, and some librarians, want to have their books so treated. I enjoy doing it, though my life would have been much easier if I had not bothered to age new bindings and had repaired bindings instead of restoring them. My intention is not to deceive, and in virtually all cases it is unlikely that the informed will be misled because the production of a really convincing old-style binding, even one of modest pretensions, considerably increases the cost. Few customers want to commit themselves to that extra outlay for a good fake, because convincing distressing of new materials, when old ones are not available, is very labour-intensive. Even when old materials are used, a lot of localized ageing is necessary if the right effect is to be achieved.

The simpler the binding—late eighteenth-century 'boards', for instance, when contemporary paper can be used—the more it is likely confusion will arise. This happened many years ago when Sir Geoffrey Keynes, the great surgeon and bibliographer, had a book in a 'common sheep' binding he was convinced was contemporary with the book which was published in the seventeenth century. When shown the book by Sir Geoffrey, Dr. Michael Phillips, a customer of mine, thought he recognized the smell wafting from it and asserted that I had made the binding. The dealer who had sold the book to Sir Geoffrey was challenged and admit-

ted that I was indeed the perpetrator. I have to confess that I feel ambivalent about this incident. Clearly, it should not have been possible for such a mistake to be made, but on the other hand, I am rather gratified[19] that I did the job well enough to deceive a connoisseur. Having said that, I shall now be the subject of even more disparagement, so perhaps it is just as well that I am nearing the end of my career.

The bindery was very conveniently situated geographically and it did not take very long to build a fairly substantial clientele; it was not necessary to advertise my services then, and has not been since. Lord John Kerr[20], who was then with Goldschmidt's, used to bring work to my bindery, and we would discuss cricket. Quaritch's and Sotheran's were among my earliest customers, as was Bernard Breslauer. H.D. Lyon followed me from Zaehnsdorf's and remained a regular customer for more than forty years. Very early private customers included Sir Peter Smithers, M.P., who was to become Secretary General of the Council of Europe; the transsexual travel writer James Morris who became Jan Morris; and one smartly dressed upper-class man who used to bring in privately-printed books about bestiality, which were eye-openers in those less liberated days. Sir Robert Abdy, Bt., art connoisseur, made an early but unpromising appearance in my humble garret when he announced, as the law requires, I believe, that he was an undischarged bankrupt. Fortunately, I had no problems with him on that score. John Arlott, the renowned B.B.C. cricket commentator and polymath, who had a considerable collection of books illustrated with aquatints, also found his way to the top floor, and I did quite a lot of work for him for ten years, or more. It was for him in the mid-1950s, that I printed one of my very first facsimile leaves. He had a very rare eighteenth-century poem about cricket which lacked the title-page. A photograph was obtained from the British Museum Library, as it then was, a zinco line-block was made by the Commercial Process Co. (just around the corner in Lexington Street), and then I found matching old paper which I was able to print with a deep impression in a nipping-press after mixing ink to match the shade of the original. When the ink was dry, I fastened the leaf in, moistened it slightly and then left the slim volume under a heavy weight so that corrugations would be transferred to the new title-page. A certain amount of ageing may have been necessary around the edges. Since then, I have produced many hundreds of facsimiles, some so convincing that collectors' guests have been unable to identify them, but the difficulties of the process are very considerable, so the

great majority have not been up to that standard. Some collectors have been very demanding in their requirements. I had one who sometimes tore the leaves and then mended them in order to deceive.

If facsimile printing is to be successful and justify the considerable expense, a prerequisite is a very substantial stock of old paper—a vital resource I was extremely fortunate to acquire (p. 60). The search for suitable pieces can take quite some time because so many characteristics have to coincide with the original paper's: thickness, surface texture, chain and laid lines, mottling and so on, seen in the look-through. Sometimes, frustratingly, everything is fine except that the chain lines go the wrong way, or the piece is slightly too small. A problem which often has to be overcome before the blocks are made is caused by show-through on the photograph; that is, print on the verso of a thin original leaf shows through. Although this is usually only grey, if it is reproduced on the block it will be printed with the same depth of colour as the rest of the text, though probably with less solidity, so such images have to be painted out before the block is made. A useful alternative, which can save a lot of time and be more effective, is to put the photograph on a photocopier at a low setting so that the grey images are eliminated.

Facsimile printing is relatively straightforward if the print on adjacent original leaves is strong. Great difficulties arise if the book is poorly printed (as is the case with many English ones in the seventeenth century) and has been much used, so that the print is weak. This may necessitate printing on dry paper, skinning the inked block so that some ink is removed, and using light pressure. It can be nerve-wracking if there is little or no selected paper to spare. Very often, finely engraved copperplate illustrations become denser when zincos are made, and a better result is obtained if the old paper is put through a photocopier. This can be done with text too, if the ink matches, but of course there is no type impression in the paper. Much facsimile work in the past was done lithographically, so that also lacked the character imparted by depth of impression. As with other parts of the restorer's activities, I have often thought that there must be an easier way of earning a living.

A few jobs went wrong while I was in Broadwick Street, in addition to the Lambeth Palace book, already mentioned. As I recall, my first setback occurred when I was asked to put a cover on a programme to be used by the Queen and Prince Philip at the Royal Festival Hall. It was all so rushed that I had to go to a railway station to pick up the sheets sent by

the printer, the Shenval Press. I remember that I covered the boards with white leather and that, while I was doing some tooling, the fillet fell out of its handle and made a dent on the cover—the front one, of course! Nothing much could be done about it because there was too little time.

I used to bind, one at a time as they were published, a series of volumes of a fine edition of Flaubert's works for a very fastidious English collector who had fitted curtains over his bookcases. I had to bind the books in green taffeta, which gave me a good deal of trouble, for a start. Anyway, on one occasion, for some reason I cannot now recall, I treated some leaves with acetone which unusually, and much to my dismay, dissolved and spread the printing ink. Being young and insecure I was very reluctant to confess, and had much difficulty and anxiety in importing a replacement copy through the London branch of a French bookshop before the owner became impatient.

Quaritch's had a Kelmscott Press book in the usual limp vellum, which had a creased spine. I tried to soften the vellum by passing a moistened paint brush down the back of the book, but unfortunately the brush still had some colour in it, and the vellum was marked. I paid for the book, which I felt bound to do, and left it with Quaritch for sale. It was duly sold, and I made a modest profit.

On another occasion I tried in vain to bleach stains out of Japanese vellum[21], but succeeded only in raising blisters on the paper and also my blood pressure, I suppose, because I got very hot and bothered during the process. When I gave up, the book was taken to another binder who, much to my chagrin, triumphed where I had failed. All this sounds rather trifling, now, but these were matters of some concern to a fairly young craftsman who was trying to establish himself with a reputation for reliability.

I was actively involved in the affairs of the Guild of Contemporary Bookbinders, founded by Arthur Johnson in 1955 as a successor to the Hampstead Guild of Scribes and Bookbinders which he had been running for several years[22]. I joined at the start and the early meetings were held in my bindery in Soho because it was conveniently central. The first meeting was held on April 7, and those attending were Arthur Johnson, Edgar Mansfield, Trevor Jones, Arthur Last, Dora and myself. As we sat around on benches and upturned finishing-presses we had no inkling that our tiny group with no financial resources would flourish and expand into a society with international acclaim and a membership of about 700, and publish a journal which is the finest in its field.

About 1955, thanks to Graham Pollard, the remarkable bibliographer, one of whose claims to fame was, with John Carter, the exposure in 1934 of Thomas J. Wise's fraudulent activities, I was elected to membership[23] of the now-defunct Wotton Club. This was a dining club (named after Thomas Wotton, a sixteenth-century bibliophile sometimes referred to as the 'English Grolier') most of whose members had a scholarly interest in the history of bookbinding. The only other practitioners of the craft whose attendance I recall were Roger Powell and Peter Waters. On these occasions I was greatly inhibited and felt, as indeed I was, hopelessly outgunned, so to speak. Sir Robert Birley, then Head Master of Eton and chairman of the Club, was an animated conversationalist when he circulated at the cigar stage, and would speak of Socrates and others of the classical period with such familiarity that one felt he had been on intimate terms with them. Fifteen to twenty people would be at table, at Brown's Hotel in Dover Street, including Howard Nixon, the Hon. Sec. and J.B. Oldham. From time to time, jokes would be told in Latin; of course, I was unable to join in the laughter with much credibility, so I probably assumed an enigmatic smile. I blush when I recall my inadequacy on such occasions.

It was for reasons such as these that I declined when, on separate occasions, both Sydney Cockerell and Roger Powell offered to put me up for membership of the Double Crown Club in the early 1970s.

# A HOME OF OUR OWN

After seven years in Broadwick Street, we needed to expand, and having occupied the upper half of my parents' house in Kenton for a few years, we wanted to have accommodation of our own. Early in 1960 we bought my present house in Clapham (fig. 19), which is south of the Thames and very close to Central London. Conditions were still very difficult. We had to wait three months for the installation of a telephone. Built in 1874, and part of a terrace, it has a semi-basement and three upper floors. Dora's elderly mother was invited to leave Kenton and occupy our top floor. The bindery was and still is in the semi-basement, and Dora and I lived on the two middle floors. Mother-in-law died after a few years, so my parents were invited to sell their home and move into the top floor so that they could more easily be looked after in case of illness, and they were accommodated for seventeen years. My father was an excellent cook, which was a good thing as my mother was disabled with arthritic hips.

They were self-sufficient until the last two years, when they were cared for by Dora. My father stayed on at Sangorski's until he was seventy-five, but worked only part-time towards the end. At a time when my parents were in the house, and we had a full-time assistant, we were also servants to twenty-seven cats, so it was a busy establishment. The feline population rather got out of control because Dora had been the RSPCA's Assistant Secretary in our area for ten years; she became known as the 'cat lady', so waifs and strays were brought to our door and duly found succour. This was good news for the local pet shop which made two substantial deliveries of supplies every week. Feeding time was quite a spectacle and a complicated occasion when certain cats would eat with each other, but not with others.

*Fig. 19.* No. 3 Gauden Road, Clapham, second house from the left.

I love cats individually, but *en masse* they have tried my patience inordinately. On one occasion I found that a pile of newly-bound books which were ready for collection had stuck together, the cause of which calamity need not be spelt out. It occurred to me to pour ammonia between them, a cunning wheeze which worked like a charm, and there was no residual staining. If only all my remedies could work so well.

Another, more serious mishap which put me in such a furious rage that I must have been in danger of suffering a stroke, happened in the late 1960s. Due to crowded bench space I had foolishly stood an old book on the floor to dry during the final stages of the work. While I was out of the room a nearby gluepot which was standing on a gas-ring tipped over. The requisite force must have been exerted by a cat or a poltergeist, but as we had hordes of the former and no previous experience of the latter I was inclined to look in the direction of a four-legged friend. Fortunately, the glue was solid, but the book was drenched in dirty glue-water and had of necessity to be pulled and washed, and so on. Such was the degree of my annoyance that I took hold of a finishing-press and brought it crashing down on to a large paring-stone, which I constantly used as a working sur-face, and broke it. On no other occasion, in business or in private life, have I been guilty of violence. The late Berthold Wolpe, emminent type-designer, kindly invited me to Faber & Faber's place, then in Russell

48

Square, to choose a replacement. What I most clearly remember about the visit was his showing me T.S. Eliot's office. Our cats have damaged some millboards and skins of leather, but there have been no other serious incidents apart from a vellum-covered autograph album sent from Chequers, which had to be re-covered. The cats could be kept out of one bindery room when I was not there, but they had to go through another one to reach their flap in the back door, so inconvenient precautions had to be taken for the safety of the many books. I write in the past tense because the last of the cats have been despatched to cats' homes, well run by Trusts in the country.

Although I was no longer able to participate in archaeological excavations I still enjoyed the company of interesting people. At 5 p.m. on many Saturdays in the 1960s and 1970s when the British Museum Reading Room closed, a group of us gravitated to a teashop in nearby Coptic Street. The group consisted of genealogists, professional and amateur, and others with varied antiquarian interests. One of them, C. Hall-Crouch, City Editor of the *Morning Advertiser* for more than fifty years, had a house filled with books, many of them about the county of Essex. The books were treble-banked, and even the library steps had a pile on each step. When he took books home he hid them in the outside loo until his wife was out of the way and he could slip them into the house. He had also built up a collection of scores of thousands of English armorial bookplates, half of which were annotated with family connections. These are now held by the Society of Antiquaries. Another notable was Cregoe D.P. Nicholson, a professional genealogist and Chairman of the Society of Genealogists, with whom I lunched on most Saturdays for nearly twenty years. On an amateur basis, he made a great study of Roman tesselated pavements and wall plaster, the latter principally from Lullingstone Roman Villa, on which we worked together. The conversation in the Coptic Street teashop was never trivial, and I found it completely fascinating and edifying.

Wine-making was a diversion for me during the 1970s. Most of it was hock-type (made from concentrated grapes), but others were country wines (made from oranges, potatoes, and so on). In order to give the potato wine more character, ginger was added; at first, the ginger was too strong, but as the months passed it receded and became quite subtle. Unfortunately, by the time the wine had matured, frequent tastings had seriously reduced its quantity.

Dora and I used to drink the hock-type wine while it was still quite young, but after a time we decided that we should lay some down to improve before allowing it on to our dining table. Towards this end, I filled seven five-gallon barrels and put them to rest in the cellar under the front steps to the house. Soon afterwards, that area needed to be water-proofed, so I put the barrels in the back garden for what I hoped would be a short period. But as tends to be the case with builders, there were end-less delays, so my barrels were subjected to wildly fluctuating conditions and I ended up with thirty-five gallons of vinegar which I poured down the drain. The barrels were sawn in two to serve as flowerpots and I made no more wine. Another hazard of the wine-making process was the occa-sional popping out of corks during unexpected secondary fermentation; as the bottles were laid down in racks, a good deal of mopping up was required. The experience was interesting, but, as will have been gathered, not wholly successful.

One of my customers, from the mid-1950s, was the distinguished antiquarian bookseller Ben Weinreb (1912–1999) who specialized with very great success in architectural books. He was one of those charismatic people in whose company one felt more than unusually 'alive', and I found him a congenial and considerate person for whom to work, and not penny-pinching. In the early 1970s he offered to buy me out so that I could work solely for him, but I soon decided that I would prefer to remain independent. I am now thankful that I did so because, otherwise, I would have been little more than an anonymous bench-hand. The work would have been relatively straightforward and undemanding, but I would have been unable to enjoy much craft-related travel, a wider diversity of books and challenges, and the interest of meeting people of all classes with a broad spectrum of interests. Afterwards, we remained on very ami-cable terms; he entertained me to lunch at the Garrick Club and I accepted the occasional commission until about six years before his death.

A fairly frequent visitor to my bindery, first in Soho and then in Clapham, was the late W.H. Langwell, F.R.I.C., a chemist and amateur binder who took a strong professional and pioneering interest in the chem-istry of materials and adhesives, and in the improvement of binding struc-tures. He wrote *The Conservation of Books and Documents,* published in 1957 and not now widely known. The lamination of paper with heat-set tissue and nylon gossamer was a great interest and he did much early experimentation in that field. In the late 1950s he was interested in pro-

ducing an alternative to egg glaire for gold tooling and I tested some of his suggestions; the only one I can recall is blood albumen, which I found to be lacking in potential. Eventually, he developed the now-popular bleached shellac B.S. Glaire. I tried out a number of his other schemes, some of which had no value, but that had to be expected. At one time he proposed that I mix into my paste the chemical disodium dihydrogenpyrophosphate as an inhibitor, but when I used it to paste leather, a thick white bloom appeared on the surface. So that was the end of that. He commonly sided his bindings with unbleached tailor's canvas which he had previously impregnated with gelatine, and used it cut at 45° to the warp for the aesthetic effect. I possess some of his bindings and can testify to the efficacy of the process.

During our conversations he would on occasion refer to my (by his standards) sloppy approach to matters scientific, and exclaim "That will not do, Middleton!"

The late 1950s and 1960s was an especially busy period for me because in addition to being fully occupied in the bindery, I was for seven years a City and Guilds Institute Chief Examiner. For a short time in this endeavour I worked with Alex J. Vaughan, well-known teacher at Camberwell School of Art & Crafts, and author of *Modern Bookbinding*; John Mason[24], teacher at the Leicester College of Arts & Crafts and author of several manuals; and Blair Hughes-Stanton, the celebrated wood-engraver. It was quite hard, time-consuming work, setting the questions[25], attending moderating committee meetings, marking several dozens of papers in the Intermediate and Final grades from entrants in Britain and the Commonwealth, and then judging the practical work in a hall at Petersham near Richmond in Surrey. A City & Guilds first-class certificate carried more weight then than it does now, I gather. During the same period I was writing my *A History of English Craft Bookbinding Technique* (published in 1963), and the Guild of Contemporary Bookbinders took up a fair amount of time. Meetings were held for some years in the back room of my bindery in Clapham. At some there were long and earnest discussions which resulted, in 1968, in the adoption of a Constitution for the Society and a change of name to Designer Bookbinders. For the first time, we had Fellows who were elected by the Fellowship on the merits of their practical work, Associates who joined through an interest in the craft and the wish to further the work of the Society, and Honor Fellows who were elected because they had rendered singular service to the

craft and/or to the Society. Original members of the Guild, like me, became Fellows without election. In 1972 I was privileged to serve one two-year term as President. The highlight of my tenure was an exhibition at the Royal Library, Copenhagen. I was certainly fortunate in that the office was a great deal less onerous than it has since become.

I served for some years as an External Assessor for bookbinding courses, principally at the London College of Printing and at the Camberwell School of Art & Crafts. An unexpected bonus from this activity came my way when Marianne Tidcombe and I took a taxi from Sally Lou Smith's bindery in Chalk Farm to Coptic Street, close to the British Museum. When we got out, the driver, whom I did not recognize, refused payment because, he said, I had given him a Pass at Distinction level in bygone years.

Eric Horne (fig. 20), our first assistant, joined us in 1961[26] at the age of thirty-five and stayed for twenty-five years until he retired. An interesting man, he had been a second gardener and general handyman, but became interested in books, and after dabbling with a little do-it-yourself book repair decided to learn it at a professional level. He approached Roger Powell who, having decided that Eric would not fit into his own set-up, took the trouble to write to me—the gist of his words being "This

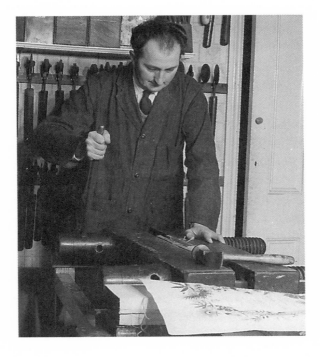

*Fig. 20.* Eric Horne, c. 1970.

52

man should be helped." When Eric got in touch with me I somewhat reluctantly took him on, but did myself a considerable service in so doing, and not just in relation to the craft. He proved to be an adept pupil and became one of the best restorers in the field, within a narrow range of activities. Modern binding held no interest for him at all; when I was tooling a designed binding and had made hundreds of impressions, he would often remark, with a note of unhelpful apprehension, "One mistake and you could ruin it." A highly principled man, he was a completely trustworthy person with whom to work and insisted on telling me about mistakes which I could not otherwise have known about. He was also extraordinarily thorough; so much so that if I asked him to put a piece of paper around a book so that a customer could take it to his car, a fine parcel with triple knots would appear. For someone who was very good with his hands, it was rather odd that for some reason I could not fathom, he never did acquire the knack of paring leather with a spokeshave, a skill which would have been of significant economic advantage to me.

Eric Horne had, and retains, a great interest in antiques, and would obsessively study and collect a particular subject for a few years and then suddenly drop it and turn his attention to something else. This involved selling the old collection in order to build the new, which is how, having selected the pieces which most interested me, I am now able to enjoy (figs. 21a and 21b) early watercolour boxes, flintlock firearms, exquisite Indian miniatures on ivory, Wenceslaus Hollar etchings, and a great variety of collectibles, all in fine condition. He received more from me than he would from a dealer, and I also gained. One of his activities during the late '60s and early '70s was excavation of the foreshore of the Thames— London's principle highway for many centuries—at Queenhithe Dock, which dates back to the eleventh century and is the oldest in London. He unearthed many interesting artefacts of early date, including weapons which he meticulously restored and are now to be seen in the Tower of London.

A few months after Eric Horne's retirement in 1986, I succeeded in persuading Flora Ginn (fig. 22) to join us as a part-time trainee/assistant in restoration, and again I was blessed with the assistance of a wholly reliable person and one who is exceptionally popular with all whom she meets. Flora was born in 1959 in Hong Kong, but came to England when she was fifteen to be educated in a convent boarding school. During the period 1978–82 she went to the City & Guilds of London Art School to

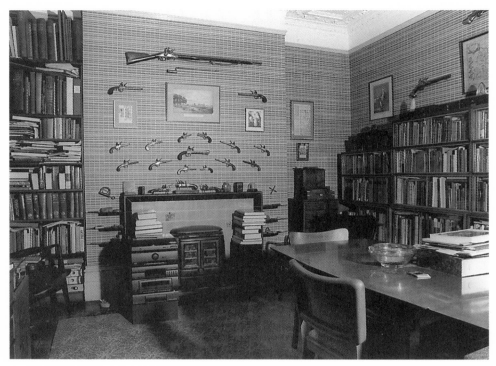

*Fig. 21a (above).* My study, 1994.
*Fig. 21b (below).* Another view of my study, 1994.

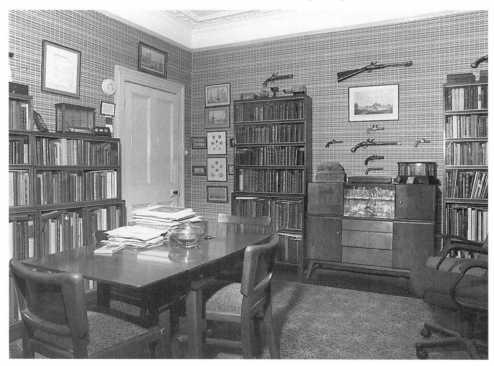

study graphic arts, and specialized in lettering. Subsequently, she attended the Digby Stuart College for further training in calligraphy, but concentrated on fine binding and graduated with a Distinction. Her success has been rapid; she was elected a Fellow of Designer Bookbinders in 1990, has many subtly designed and finely gold-tooled bindings to her credit, and, I believe, has become one of the very best restorers of leather and cloth bindings to be found anywhere. Her sepia ink titling on my old-style vellum bindings is convincing, as are her pen facsimiles on paper repairs in early printed books, which are of a far higher standard than I could hope to achieve. As might be expected, her expertise in the manipulation of chopsticks is such that I prefer not to use them in her presence. I look forward to the day when I have a Chinese customer and Flora's Cantonese can be employed to good effect. When not helping me, she practises in her own very well equipped bindery (cobweb free, unlike mine) which is similarly situated in a large Victorian house not much more than half a mile away.

Good tooling on designed bindings is out of fashion and comparatively little is being done, much to many collectors' dismay, and high-

*Fig. 22.* Flora Ginn in her bindery at 25 Ferndale Road, Clapham, 1999.

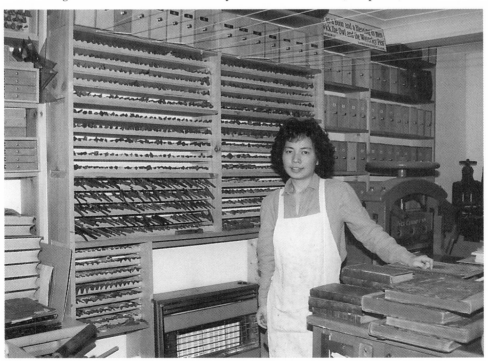

quality restoration is not as prevalent as it should be, so on both counts, Flora should flourish.

Life in a miscellaneous craft bindery such as mine tends to become very complicated with many books being worked on concurrently for dozens of customers in Britain and abroad. My work has embraced the restoration of bindings of all types and periods; the rebinding of books in period styles in leather, vellum, cloth and paper; occasional rebinding of modern books in traditional 'West End' styles; and box-making, ranging from simple cloth to full goatskin with elaborate gold-tooling. Also done in-house has been the previously mentioned facsimile printing, and the restoration of paper, though nothing highly sophisticated like invisible mending or the cleaning of seriously discoloured colour plates. A task I have enjoyed immensely in this field is the resizing, with gelatine, of very heavily water-stained books, because in most cases the stains readily disappear and the paper is gratifyingly rejuvenated. Sometimes, ingenious pieces of furniture with leather attachments, of the kind found in the libraries of large country houses have arrived for restoration; likewise, huge richly decked-out portfolios which have been worked on and completed very quickly in order to "clear the decks". In addition to all this, I have had to produce a designed binding from time to time for collectors or Designer Bookbinders' exhibitions, but I have seldom managed more than two annually. I have related the foregoing in the past tense because I hope that, shortly, by the time of my seventy-fifth birthday, I shall have contrived greatly to reduce my output of restoration and period-style bindings.

Every job has quite a few details which have to be determined, some of which may appear to be trivial, but turn out to be vital to the owner if they are not correct. It can be difficult to know what a far-distant customer has in mind and how he or she envisages the completed work, whether it be a new binding or restoration, so some anxiety is felt when there is so much potential for subtle divergence from expectations and not least when quite a lot of expense is involved. Much of the work, especially that done for dealers and auction houses, is urgent, partly because the value of many of the books is considerable, and very often those which were not urgently required when they were accepted are suddenly called for. Proliferating book fairs tend to make life difficult and then, of course, there are sudden emergencies, mostly involving burst water pipes in both institutions and private homes. It is well nigh impossible to please everyone.

The oldest book I have restored was an eleventh-century Greek manuscript, which came to me very early in my career. The largest were two sets of Audubon's double elephant folio *Birds of America.* But the heaviest book by far, was a very large and thick folio with massive wooden boards and metal attachments which Napoleon Bonaparte took with him when he embarked on his campaign in Egypt. Even though I was much younger then, I had great difficulty in lifting it. Now that I am in my mid-70s, the handling of volumes of Gould's *Birds,* with their thick, rope-fibre hand-made boards, demands more effort than formerly. It is not until one comes to grips, so to speak, with ponderous tomes that one realizes, especially in old age, how frequently books are lifted and turned over in the course of binding and restoration.

As will have been gathered, the two main divisions of my practical work are 'the old' and 'the new', with the former predominating. The old work requires me, for the most part, to work deliberately inaccurately and, let's face it, muckily, so that the restoration, or the new binding in period style is sympathetic. Conversely, when I rebind Victorian or later books in 'extra' style, and when I produce modern designed bindings for exhibitions or collectors, I need to be very precise and clean in everything I do. These are very disparate activities, physically and mentally, and each has subdivisions which are practised by specialized craftspeople in trade binderies, but which have to be embraced by people like me who work alone. Partly for these reasons and the pressure of other work, and also because the creation of my designs, such as they are, is hard work for me, I have produced only one hundred or so designed bindings.

All this is done in an area inconveniently divided into rooms and passages (figs. 23 to 26) containing many shelves for books (in the 1970s and early 1980s, nearly thirty 36-inch shelves were packed with books awaiting attention) and large stocks of materials, tables, presses, a board-cutter, cabinets filled with old paper, a fumigating cabinet, and so on—the paraphernalia usually associated with a professional bindery. Bench space is very limited, so work on very large folios, with which I have frequently been burdened, is very difficult and involves much moving of other books and clutter from one place to another, and then back again. However, all this, combined with the walls being covered with many hundreds of finishing-tools, photographs of my bindings and items of book-related interest, plus dirt-laden cobwebs hanging from the ceilings, combined with an all-pervading aroma derived from rotting leather and paper, paste, glue

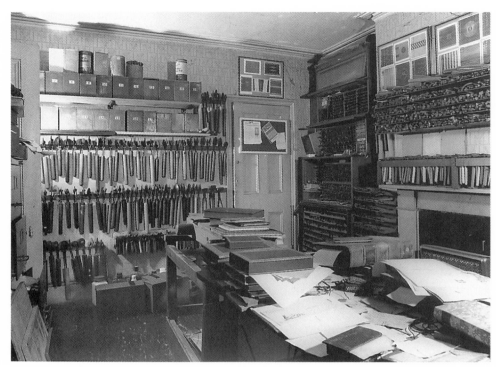

*Fig. 23 (above).* The front room of the bindery at 3 Gauden Road, 1994.
*Fig. 24 (below).* Another view of the front room of the bindery, 1994.

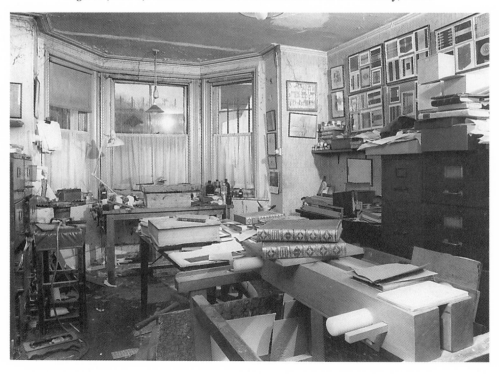

*Fig. 25 (above).* The back room of the bindery, 1994.
*Fig. 26 (below).* Another view of the back room of the bindery, 1994.

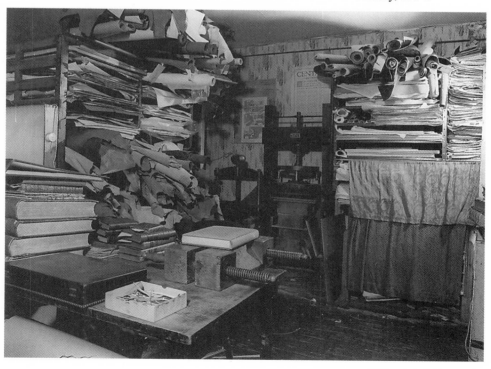

and sundry chemicals and liquids, creates a chaotic, old-fashioned atmosphere. It may be anathema to visiting conservators from institutional laboratories, though they tactfully do not apprise me of the fact, but lay visitors seem to like it because they bring their friends and relations to enter what they regard as a curiosity in the age of the computer and its clinically-clean environments.

The inconvenience of the set-up extends to paper-mending. Ideally, of course, this is done in a sealed-off clean area and not in one in which powdery old calf is scraped off and dirt is everywhere. However, such problems can be overcome.

Getting on thirty years ago I was able to buy a mass of old paper from a recently-retired print dealer in London, which filled a taxi one and a half times. The paper ranged in date from the sixteenth century to the late nineteenth. The collection included albums of about 1830–50 with fine, plate-embossed leather bindings, volumes of coloured papers of the same and earlier dates, eighteenth-century folios of blank laid papers, much very early nineteenth-century wove paper, and so on. Found in some albums were charming watercolours, executed about 150 years ago, probably by leisured young gentlewomen, which are now framed. Speaking on the telephone with the owner, and without having seen the extent of the collection, I expressed some concern at the asking price of £50, so he immediately reduced it to £30, which is what I paid. It was the most incredible bit of good fortune for someone in my situation, and its value to me as a resource has been incalculable. It greatly supplemented an earlier purchase of paper, including some of Eastern origin, which had belonged to Albert Seth, who was formerly with the renowned Riviere bindery, but was foreman of the Mending Department at the British Museum Bindery when I was there. It came to me through his son, Albert, who was a senior apprentice when I was a junior. Apart from the unfortunate Lambeth source, much old paper has been accumulated during the past forty-odd years from the preservation of flyleaves from books which, for various reasons, had to be rebound, and by soaking off pastedowns of discarded boards, some of which were kindly given by dealers. A great deal of old marbled paper has been salvaged by these means.

In 1972, after the accession of the large collection of old paper, H.J.D. Yardley, an accomplished amateur binder who had been trained at the Central School in the 1930s, and became a Fellow of Designer Bookbinders[27], died and bequeathed to me the complete contents of his well-

ordered and stocked bindery, which I received in the following year. This unexpected windfall included four sets of Bruce Rogers' Centaur handle-letters, which were not standard issue, so to speak, and were in large sizes—I think they must have been specially cut for Yardley. At the time, I was binding in one volume, a copy of Rogers' Lectern Bible which was printed in 1935 in Centaur type for the London dealer, H.M. Fletcher. I had reached the final stages and was wondering what to do about the lettering on the spine because my sets of large handle-letters were Victorian and quite unsuitable. And then, most opportunely, the Centaur tools arrived. Very gratifying! Less gratifying, though was the sewing of the Bible, which was irksome, to say the least. Before embarking on the task, I consulted Roger Powell who had experience of binding this hefty tome. Roger said that he had finished up with insufficient swell in the spine, which needs to be adequate for good and durable shape, so I used a thicker thread than he did. Unfortunately, the resulting swell was excessive and made satisfactory binding quite impossible, so I had to pull the book and start again with a slightly thinner thread. The book has a very large number[28] of thin signatures (which is why the slight variation in the thickness of the thread is of vital consequence), and the sewing was on six double-raised cords, so it all involved much gritting of teeth in the pulling with the waste of a day's somewhat tedious work, and resewing.

Slightly unusual jobs have come my way from time to time, as they have for most binders. In the 1970s I bound blank books for models to hold in Madame Tussaud's Waxworks exhibitions. In the case of Erasmus, I bound the book appropriately in sixteenth-century style, but I had to remember not to age the binding, as I normally would, because a volume of his own work would have been fairly new—such an obvious point, but I could easily have overlooked it. In several parts of the book I had to insert a pair of facsimile leaves so that the figure could hold it open at those places and appear to be reading. When the leaves became horribly greasy and grubby because of the frequent touching by visitors, the book would be opened at another place to reveal clean facsimiles. I remember doing the same thing for a model of Hans Christian Andersen.

The biggest project on which I have been engaged, together with a number of other binders and paper restorers, is the restoration of books in the Valmadonna Library, the world's largest and most important privately-owned collection of early Hebrew books. Based on an existing family collection, it has been greatly augmented during the past forty years by Mr.

J.V. Lunzer, an English industrial diamond merchant with world-wide connections, commercial and otherwise, at the highest levels.

Restoration, which started in the early 1970s, and still continues, has been difficult, complicated and labour intensive. The condition of the books fully reflects the suffering of the Jewish people, and the crude work of earlier binders (whom I have cursed on innumerable occasions) has greatly increased technical problems and expense. Few early Hebrew books retain their original bindings, so virtually all of them, except the less significant ones which I have not handled, have been rebound in full old-style goatskin (fig. 27) or, in a small minority of cases, in vellum or tawed pigskin. All the fully-bound books have been provided with leather-edged slipcases, except some extra-special books which are contained in gold-tooled, full-leather drop-back boxes. Hundreds of my bindings stand in the Library and constitute the largest assemblage of my work.

In 1989 I was generously flown to New York by Mr. Lunzer to attend the opening of an exhibition at the Pierpont Morgan Library, of fifty of the most interesting and important Valmadonna books. The excitement of the occasion was heightened for this humble artisan by the wonderful experience of being a guest at the Pierre Hotel, one of the finest in the city, and being transported in a stretch limousine, complete with black windows. I felt that I was in a miniature nightclub on wheels.

Fig. 27. Early-sixteenth-century-style binding covered with darkened native-dyed Niger goatskin and tooled in blind. I have produced hundreds of somewhat similar bindings, though comparatively few with clasps.

As a Gentile, I feel that it has been a considerable privilege to be entrusted with this work, and I certainly feel that in helping to preserve such an important part of the Jewish cultural heritage my time has been well spent.

About two decades ago, for a period of two years or so, a man named Joseph Gradenwitz often came to my bindery on Sunday mornings for instruction in restoration. His family had been prosperous wool merchants in Germany before the Second World War. Because of the Nazi threat against the Jews they fled to Britain and left behind most of a fine collection of early Hebrew books. They re-established themselves as merchants in England, but were eventually squeezed out of the trade by the major companies. Joseph took up bookbinding and did well at it. One black day we both attended an afternoon auction of binding tools at Christie's, South Kensington, on Friday July 24, 1981; we both were successful with some of our bids and we queued together to settle our accounts. That evening, after sunset, he started out to visit a friend in hospital, and as it was the Jewish sabbath he had to walk rather than drive from his home. While on his way he was knocked down by a car and killed. It was a sad and shocking event, and a waste of scholarship combined with skill.

During the forty-five years I have been self-employed, I have, with reasonable frequency, been able to escape from the long hours of intensive work in my bindery. During the 1960s and 1970s, Dora and I felt that we should travel while we could, so for two weeks each year, whenever we were able, we saw some of the sights Europe and adjacent areas have to offer. It is very fortunate that we did, because later on Dora became too infirm to travel. Usually, we went on package holidays rather than luxury jaunts, but they were very good and our fellow tourists were civilized people. We travelled in various parts of Britain, including the wonderful Scottish Highlands, also to Athens (carefully arranged so that we could go up to the Parthenon at full moon as well as in daylight), the Greek Islands, Istanbul and other parts of Turkey, Switzerland, the Norwegian fiords, Venice and Florence, Yugoslavia and even to the hard-to-penetrate Albania.

My first work-related trip was to Florence, very early in 1967, at the invitation of Howard Nixon, to help cope with the aftermath of the disastrous flood. I worked there for a few weeks with Sandy Cockerell, Elizabeth Greenhill, Stella Patri, Roger Powell, Peter Waters, and others. It was a profoundly depressing experience to be surrounded, in the perishingly

cold Forte di Belvedere, by scores of thousands of what, not long before, had been fine early books. They had been taken there after being rapidly dried (in order to inhibit the growth of mould) in pottery kilns and tobacco driers, and the task allotted to a few of us was to go through the books and insert slips of paper marked with symbols which indicated recommended treatment. My gloom was alleviated when the British Consul sent a case of champagne to the *pensione* in which we were accommodated. I remember seeing a waiter shaking one of the bottles before opening it and the cork hitting the very high, ornate ceiling.

In the mid-1970s, Eric Horne and I worked for a week, or so, at Chequers, a large mid-sixteenth-century house in Buckinghamshire, which is used as the Prime Minister's official country residence as it has been for about eighty-five years. The house is not opened to the public, so this was a wonderful opportunity to see inside. Our task was to furbish books in the Library, which we did with the aid of a team of Wrens (Women's Royal Navy Service), the reason for this being that the domestic duties are carried out by service personnel. For security reasons we were accommodated in a hostelry outside the gates of the estate. The more serious restoration work was brought to my bindery.

I have done the same kind of work, on a number of occasions, at Waddesdon Manor, a National Trust property not many miles from Chequers. The great house was built for Baron Ferdinand de Rothschild between 1874 and 1889 in the French Renaissance style, and is filled with French works of art of many kinds and of the highest quality. It includes a library of many hundreds of finely bound books which are taken out and dusted by the staff, annually, and thoroughly furbished, periodically. In the regrettable absence of a team of young Wrens, I have done all the work myself, but on two occasions with the aid of Eric Horne. We were accommodated either in the house or in The Five Arrows Hotel, just outside the gates, built for Baron Ferdinand in 1887.

# America and Beyond

In 1974, Robert Akers and Michael Hutchins, of the Camberwell School of Art & Crafts, and I were invited by Mrs. Beineke to attend a conference in North Adams, Massachusetts, with all expenses paid. It was concerned with the establishment of a crafts centre and related activities in a huge disused textile printing mill. Planning for this ambitious project had been going on for a few years, and it was all rather heartening, but the scheme never came to fruition in the manner envisaged. This was my first visit to the States, following my frustrations during the War, and was very exciting for me. I took the opportunity to go to New York and stayed at the Algonquin Hotel because of its literary associations— Dorothy Parker, and all that. Actually to walk down Fifth Avenue for the first time, to be in Grand Central Station, seen many times in Hollywood films and which seemed so remote, and witness many minor sights such as lounging, overweight policemen with a hand hovering over their pistol like members of the Mafia, gave me quite a 'buzz' which, after many subsequent visits, has not entirely evaporated.

A few years later, my very good friend, Mel Kavin, proprietor of Kater-Crafts Bookbinders of Pico Rivera, near Los Angeles, persuaded me, with some difficulty, to conduct workshops on the restoration of leather bindings. He then went to the considerable trouble of arranging a two-months tour across the States for me. Having to some extent overcome my stage fright, a condition which still afflicts me, and with Mel's input, in the next two years I launched myself on similar long tours and taught in universities, commercial binderies such as Sam Ellemport's Harcourt Bindery in Boston, in which he ran classes, and in private binderies such as Fred Jordan's in Livonia, near Rochester, New York. Since then, I have embarked on much shorter tours. Most of the workshops have lasted

three days, but a few have extended to four or five. Meeting so many (perhaps several hundred) well-motivated and enthusiastic people has been a most rewarding experience and, of course, it has been a two-way learning process. It is unfortunate that most binders and restorers on that side of the Atlantic have to rely very heavily on a series of short workshops because, apart from the considerable expense, with a long list of instructors they are likely to be given confusingly different opinions and policies. Disparate views are less confusing, and can be taken selectively, by those who have had the benefit of a long foundation course with a small number of teachers. Some have been able to travel to England and to Ascona in Switzerland for such training.

My workshop tours have given me the opportunity to take side trips to see wonderful places such as the Grand Canyon, Hawaii, Yosemite National Park and Death Valley, mostly as the guest of Mel Kavin, Fred Jordan and other workshop hosts. In 1992, when I was due to conduct a workshop at Brigham Young University in Provo, Utah, Robert Espinosa, the Conservator there, nobly drove me for five hours through torrential rain from Salt Lake City to Bryce Canyon where, the next day, the weather was fine. After that, I was taken to Zion National Park. It was a wonderful experience. I have enjoyed overwhelming hospitality everywhere, but for various reasons including the fact that I am a non-driver, I have been unable fully to reciprocate it. Americans think nothing of driving me for an hour to an airport or railway station, whereas I think I have done rather well if I walk a visitor down the road and point out the bus stop.

It must have been about 1980 that I visited Harold Tribolet (whom I had met on a few occasions in London) when he was in retirement in the splendidly situated Larkspur in Colorado. I enjoyed chatting with him in his packed and interesting study, the walls of which were lined with mementoes of his impressive career[29], including, as I recall, at least one Commendation, or something of the kind, from the President of the United States. After driving to the local rubbish disposal area, and exchanging pleasantries with one of his neighbours, a retired Army General, we went on to Colorado Springs where I enjoyed descending 1000 feet in a disused gold mine. During the day we gravitated to a saloon bar which I was gratified to see had the traditional 'cowboy' swing half-doors. As I pushed through them I may have vaguely hoped that everyone inside would fall silent in true Hollywood film style, but of course those who propped up the bar were clearly unfazed by my threatening presence.

I have also worked in Belgium, Holland, Switzerland and Venezuela and been treated with the greatest kindness and generosity. The British Council contributed to the cost of my going to Caracas for a spell of teaching at the Biblioteca Nacional early in 1986, but in a department on the outskirts of the city[30]. It was interesting to see that in the main building, presumably now vacated because I saw a new building in the course of construction, books were moved from one floor to another by means of buckets lowered on ropes in empty lift-shafts. The extensive damage done to individual books was dreadful to behold, and a restorer's nightmare—great chunks were eaten away.

I took the opportunity to fly down to Sao Paulo, Brazil, to stay with Ursula Katzenstein, a German binder who had lived there for about fifty years, and gave a demonstration for other binders and interested people. Although terminally ill with cancer and no longer practising the craft, she was still very interested and helpful. Coincidentally, while writing this I have received an invitation to return to Sao Paulo and Rio to teach. After my stay with Mrs. Katzenstein, as I had long wished to do, I went to Rio and did the usual touristy things, such as going to the figure of Christ on the highest peak, Corcovado. An antiquarian bookseller arranged for me to rent an apartment close to Copacabana Beach which was very pleasant, but the great heat and high humidity exhausted me, as did the general noise level and not least that associated with the *Carnaval*. I had been warned about the high crime rate, so the rather frequent attempts to pick my pockets failed. I gravitated to the Biblioteca Nacional, of course, and was given a tour of the building in part of which air conditioning had recently been installed. It was sad to see the lack of resources in the Bindery with early books being covered with some sort of plastic-covered paper because there were no funds for the importation of appropriate materials. Even the sewing-frame was home-made. When I was in Rio in August, 1999, and was invited to visit the department, it was a great pleasure to find that it was well equipped and staffed and that excellent work was being done.

During my overseas trips I have often been taken around the stacks in universities and other large libraries, such as the Huntington, in San Marino, California. My output has been quite considerable over the last forty-five years of self-employment. On a number of occasions I have spotted old friends, so to speak. When I have liked the look of my work I have eagerly drawn attention to it, but if the repair leather had faded, or there was some other disquieting feature, I passed on without comment.

The feature which usually 'hits' me as I glance along the shelves is the style of lettering and associated ornamentation in the same panel, more especially if there is a lettering-piece. The handle-letters I use (I have forty-six sets) are mostly old ones and unlike those presently on offer in engravers' catalogues. I suspect that many other binders are similarly able to identify their own work.

For about thirty-five years, until they closed down, I used Carr, Day & Martin's[31] spirit stains on repair leather in my bindery, in demonstrations, and I also wrote about it. Collectors, dealers and librarians have often shown me bindings thinking that they were my work because of their distinctive aroma, which some loathed. But often they turned out not to be mine, and in some instances I was horrified and hastily disclaimed responsibility because the technique was of poor standard—probably students' work.

In the late 1960s the American Library Association commissioned me to write *The Restoration of Leather Bindings*, following a visit from Harold Tribolet, the Chairman of the Advisory Committee, to sound me out. The book was published in 1972. It was the second volume in a series intended to extend to about twenty-five volumes covering all aspects of conservation. However, funds dried up and my book was the last to appear. The A.L.A. published a second edition in 1984, and a third edition was issued by Oak Knoll Press in 1998.

In the book and in workshops I have advocated the use of overcast cloth joints (pp. 94–99) as a means of reinforcing the reattachment of detached boards before rebacking, a technique which has given rise to adverse reactions in some quarters. The principal criticisms have been that the overcasting restricts the opening of the first and last leaves, and that the overcast parts of the book may eventually break away from the rest of the text-block. This could indeed happen if the leaves are too thick, but if they are of the correct thickness for their area (i.e., they lie down without persuasion), there is no adverse effect, immediate or potential. Many techniques can be criticized as being unsuitable and harmful if they are misapplied.

In 1985 there was a brief and welcome diversion from my normal activities when I was summoned by the late Lord Rothschild, a secretive and extremely influential figure in public affairs, to meet him in his merchant bank in the City, whence I was whisked in a chauffered car. He subsequently sent me to Cambridge to investigate the condition of a very fine

collection of books and manuscripts he had donated to his College sixteen years previously. I spent a pleasant day in the Library of Trinity College examining the material and noting the environment in which it was kept, and duly submitted my detailed report. Not everything was as it should have been, but in the main I was able to allay his Lordship's worst fears, though he subsequently quizzed me about possible neglect.

I have never made any discoveries in bindings which have turned out to be of prime importance, such as a Caxton *Indulgence*, but one or two things of mild interest have come to light. Many years ago I had cause to remove the leather from the boards of a contemporary binding on a French Bible of about 1600. This revealed that the boards had been lined with about ninety small playing-cards which were in quite good condition and responded to treatment. The owner, with whom I had been dealing by post, expressed virtually no gratification for their retrieval, or gratitude to me for bringing them to his notice when I could have kept quiet. They turned out to be of considerable interest, and I heard on the radio that they fetched quite a lot of money at auction. Collectors and dealers have occasionally asked me to separate old pasteboards, but I am not aware that anything I found set pulses racing.

Most experienced binders and restorers of bindings and paper have had things go worryingly wrong, some of which can be rectified, and some which cannot, or only partially. Some mishaps are due to carelessness, some to distractions such as answering a telephone, some to unforeseeable circumstances, and others to incompetence. I plead guilty on all counts. I have already described a couple of set-backs I had in the 1950s. In the late 1970s I was asked by Seligmann, a London dealer, to flatten the last few leaves of a small vellum-leaved manuscript. Soon after starting to relax the thin leaves in cold steam they suddenly shrivelled up to about half their original size, much to my horror, as may be imagined. I was in a cold sweat for the next couple of days, and I could think of nothing else as I endeavoured to stretch them. As I recollect, I was unsuccessful, but I suppose there must have been some improvement because there was no adverse reaction from the owner. What I had not known when I started the work, though perhaps I should have suspected it, was that the book had been near a serious fire, the heat from which had changed the nature of the skin. Then, believe it or not, I contrived to burn a title-page to cinders by immersing it in a bath of water over a gas-ring, and forgetting about it. The book, which belonged to Albert Ehrman, an English

collector who formed the celebrated Broxbourne Library, turned out to be of little value, and I continued to be his sole binder for some years until he died. What could have been a disaster for me turned out not to be, but I learned a lesson.

On another occasion, a solicitor brought in a book of family interest. There was much discussion about what should be done, and the outcome was that I rebound the book in accordance with the notes I made in the owner's presence. Much to my consternation, when he came to collect it he was expecting a box with the untouched book inside, and he maintained that he had made notes to this effect in his car immediately after his departure. It was an acrimonious and dispiriting episode which baffled me.

Also baffling, but only because I do not know how I could have been so foolish as not to make a final check before delivery, was the occasion when I put a full-gilt spine and a lettering-piece on a rebacked eighteenth-century large folio. I duly delivered the book, blithely unaware that the tooling was upside down. Fortunately, the gilt panels looked the same either way up, and the original positioning of the raised bands was idiosyncratic, so all I had to do was move the lettering-piece to where it should have been, and then tool the empty panel. This cost little, apart from loss of face, which the owners, Maggs Bros., minimized with their customary courtesy.

Apart from the foolish mistakes I have made, not all of which have been recounted here, other worries, some severe because of the considerable values involved, have resulted from books being mislaid and indeed, very occasionally permanently lost. Books were mislaid mostly in the days when I had a huge backlog of work, by which I mean that the books awaiting attention occupied something like twenty-five standard shelves. Fortunately, most mislaid books had merely slipped to the floor from the back of the shelves or were very thin and had lain undetected under weighty tomes. Nevertheless the anxiety before they were located was considerable, and certainly affected my concentration on other matters. Within the past few years I thought I had lost a book which was worth many thousands of pounds, and was one for which the owner had searched for years before it was sent to me. The book was insured by the intermediary dealer, but I felt dreadful because the owner would be devastated and, of course, the loss would have done my reputation no good at all. After bothering Maggs, Quartich and others to whom I thought I might have delivered the book in error, I found that it had slipped to the floor

behind a table. It was almost worth mislaying the book for the sense of relief when it came to light. A book which belonged to an American dealer apparently went missing in 1979. There was the usual consternation, the book was not found and I eventually did work without charge as a form of compensation. In 1994 the dealer courageously told me that he had found the elusive volume which had not been in my possession in the first place, so this is one crime of which I can justly claim not to be guilty.

One small book was permanently lost because, I think, I failed to notice it among the packing in a large carton of quartos sent by the late Warren Howell, the renowned dealer in San Francisco. At that time, roughly twenty-five years ago, the book was valued at £1000, so to avoid strain on my current account at the bank I sent him, by agreement, an antiquarian book of that value from my private shelves.

On another occasion, a book of the same value was lost in the post while on its way to a private customer in San Francisco. Unfortunately, it was not insured because I did not notice it on a long invoice when I made up my register of sendings which had to go to my insurance company. The one book not listed had to be the one which went missing. It was an expensive oversight.

An alarming situation arose about two years ago when one of the great London auction houses sent me on behalf of one of their customers an early sixteenth-century book, the eighteenth-century binding on which needed to be restored. The book lacked the first leaf and the paper throughout was very woolly. I had not been asked to treat the paper, but I decided, much to my later regret, to resize the first six leaves in order to improve their handling qualities. After I had done this I put the leaves under a weight and forgot them. When I restored the binding I failed to notice that the resized leaves were missing because I knew that the book was imperfect anyway. The book went home, and soon there were concerned calls from the auction house and the owner about missing leaves. Within a very short period, while I was still looking for them I had a telephone call from the *Glasgow Herald*. A piece appeared the next day with talk of litigation against the auctioneers. A few days later, a reporter and a photographer turned up unannounced on my doorstep from the *Mail on Sunday*, and *The New York Times* was alerted, which was all very disconcerting and unnecessary because the missing leaves were soon located. I made, free of charge, a good facsimile of the title-page which was lacking when I received the book, and this helped to mollify the owner.

The possibility of theft in the bindery has always been a matter for concern because new customers about whom I know little, sometimes have to be left alone in a room containing many books which are being restored, while I fetch samples of materials, or whatever, but I have no evidence that anything has been lost that way. When I recall tales told by dealers I feel very fortunate.

I have referred to lost books, so perhaps I should balance the account by mentioning inadvertently acquired ones. When I was at Zaehnsdorf's there were dozens of dusty packets under benches containing books which had never been collected, and had lain there for decades. I decided to sell some of the older items including some original drawings and manuscripts of Aleister Crowley, diabolist and poet, and self-proclaimed Beast from the Book of Revelation. I do not recall what the material fetched, but I do remember that it was bought by John Schroder, a book dealer and member of the banking family. Similarly, I have accumulated books which people have left with me and gone off, never to return. In one instance, I offered a restored book to a customer knowing without doubt that it was his, but he denied ownership and would not accept it. A few years ago I disposed of books which had lain on my shelves for twenty to thirty years. Some were of comparatively little value, but others, dating back to the sixteenth century, realized hundreds of pounds each. Some of the books have been purchased by a Conservative statesman who has occupied one of the highest Offices of State. On one occasion he spotted some books lying on top of a stack of bookcases, near the ceiling, and said that he would like to examine them. I expressed some reservation about cobwebs and spiders, so he immediately volunteered to mount a high stool and retrieve the enticing volumes himself. As he stood on the narrow stool I was acutely conscious that if he had fallen and been injured, the event would have made the front pages of all the national newspapers.

Two visitors did fall down, but outside the house. The first to dive was a peer of the realm who took a pile of books out of the boot of his car, turned towards the house and tripped over the curb; he fell flat and the books went in all directions as his wife and I stood at the top of the front steps and watched the loss of dignity, and the increase in the book repair bill. The second was a well-known BBC broadcaster who came to interview me for a programme. Unfortunately, she was wearing a white or cream suit which suffered when she fell on the wet surface outside our

gate. The mishap caused her to utter the f-word, which listeners have never heard her use. One lady who contrived to arrive with her dignity intact, in the 1970s, was Mrs. Charlton Heston. The book she brought for treatment was about genealogy—a subject in which she seemed to have a deep interest.

An important part of my activities, for me, has been the collecting of books about my craft. My very first acquisition, in the early 1940s, was Vaughan's *Modern Bookbinding* (1929) which the author signed for me about twenty years later. I started to collect seriously, or as seriously as my funds would allow, in 1949, so I now have about 2,000 titles, many of which are multi-volumed. They cover both the historical and practical aspects of the craft, and are in many languages. Despite the shameful fact that I read only English, the collection has been immensely valuable to me, if only, in some cases, for the illustrations when I am producing period-style bindings. The books have saved me a great deal of time in that I do not have to make trips to libraries to consult them, and it is very pleasant and gratifying to be able to do research and write in the comfort of my study late at night wearing pyjamas and dressing-gown.

In addition to the books, there is a good collection of articles extracted from nineteenth- and twentieth-century periodicals, half a dozen filing-boxes filled with ephemera, some of it of great rarity, and a collection of several hundred binders' tickets. There is also a small collection of bindings of superb quality, some of which are on books about bookbinding, which is a satisfying combination. The earliest book in the collection is Zeidler's *Buchbinder-Philosophie oder Einleitung in die Buchbinderkunst* (1708). A notable fairly recent acquisition is a delicately-made peepshow of a German bindery by Martin Engelbrecht, c. 1750—a very rare item. It came to me as a set of six cut-out cards, between each of which I placed a gusset to provide depth for the scene, and then put it into an appropriate wide gilt frame which draws the eye to the picture. One of the rarest books is Hugh Sinclair's *The Whole Process of Marbling Paper* (1820), of which only three other copies are known to exist, and which is illustrated with twelve specimens of marbled paper.

It is a pity that the quite dramatic increase in prices during the last twenty-five years or so of all earlier material of bookbinding interest, and the high cost of current scholarly books on various aspects of bookbinding history, makes it virtually impossible for those on an average income to collect anything other than how-to-do-it manuals and exhibition

73

catalogues. In this, as in so many other fields of antiquarian interest, the small man or woman is now excluded.

The collection has been acquired by the Rochester Institute of Technology in the State of New York, where it will complement the very fine Melbert B. Cary, Jr. Graphic Arts Collection. The books will remain in my possession until October, 1999 (or soon afterwards), when I shall be seventy-five. Then, the books will be accommodated in a pleasant room which has been specially constructed and fitted out, and in a small adjoining lounge which has display cases. At present though, the majority of the books, the most useful ones, occupying about thirty shelves, are kept in my study, a room which is very important to me and is my refuge from the trials and tribulations of the world. It contains much that I need and like; in addition to the bookbinding material, I have a good range of general reference books, fax and photocopying machines, a radio and some bottles! I also have a music system, but my problem with that is that if I like the music I want to stop writing, or whatever, and if I do not like it, it irritates me. I like to be surrounded with artefacts from the past and fine craftsmanship, so the walls are adorned with antique firearms, and the tops of bookcases serve as a base for my Indian miniatures, early watercolour boxes, scrimshaws, early ship models, items of Tunbridge ware and collectibles of many kinds, virtually all of which, as mentioned earlier, came to me from Eric Horne. Everyone tells me that I would benefit from the ownership of a computer, but the prospect of coming to grips with one is daunting, so until now I have made do with an electronic typewriter.

In 1961 I was elected a Member of the Art Workers' Guild (1884) of which, in that year Sydney M. Cockerell was Master. The Guild has been accommodated in a house (1713) in Queen Square since 1914, and its fine Hall, built in that year in the garden area, has been used by Designer Bookbinders for meetings for many years.

In 1967 I had the extraordinarily good fortune to be elected a Fellow of the Society of Antiquaries of London, founded in 1707 and the second oldest Royal Society in London. I doubt that I would have been elected but for my genealogist friend Cregoe Nicholson's energetic canvassing on my behalf, bearing in mind that I have the unfortunate distinction of being one of the very few Fellows who lacks a university degree, and probably the only one who has absolutely no academic qualifications. The Society has been accommodated in specially designed apartments in Burlington

House, Piccadilly since 1875, having moved from apartments in Somerset House, which they had occupied since 1781.

Nineteen years later, in 1986, I was made a Member of the Order of the British Empire (MBE) and was invested by the Queen in Buckingham Palace. Eric Burdett and Douglas Cockerell were Members, as are Ivor Robinson, Faith Shannon and Philip Smith, all former Presidents of Designer Bookbinders. Sydney M. Cockerell, Edgar Mansfield and Roger Powell were Officers of the Order (OBE). The Investiture is a memorable occasion, and morning dress, though not obligatory, is worn by almost all the men. One ascends the Grand Staircase which is lined on either side with Life Guards, complete with their swords and gleaming breastplates; those to be invested go to the Picture Gallery, there to be instructed in the procedure, and the ladies to be taught how to curtsy. Guests, in the mean-time, have moved to the Ballroom where the Investiture takes place. A mil-itary band in the Gallery plays light music throughout the occasion. The Queen[32] is at one end with the Yeomen of the Guard and various func-tionaries behind her. Those to be invested have been taken in groups of about twelve to an ante-room of the Ballroom. When the Lord Chamber-lain calls one's name with the citation, in my case "For services to book-binding", one walks to a position opposite Her Majesty, turns left bows and takes three paces forward. The Queen hangs the medal on a hook previ-ously attached to one's coat, a few words are exchanged, hands are shaken and three steps are taken back. One bows, turns right and leaves the Ball-room, thankful that one has not tripped over the carpet (fig. 28).

I have been delighted to accept Fellowship of the Society of Book-binders, and Honorary Membership of Chicago Hand Bookbinders.

My bookbinding career has been hard work with long hours, nearly all of them spent standing, and there has also been a good deal of respon-sibility—though no more than that experienced by many others—and anx-iety. The anxiety has been due in part to the fact that because I have been writing for nearly fifty years my reputation has become greater than my ability, practical and otherwise. It is pleasant to be well-known, and I would be a hypocrite if I were to say otherwise, but the embarrassing aspect of it is that people often expect one to know and to be able to do everything; in fact, I often feel rather like a novice because there is so much that I do not know and cannot do.

At the time of writing (November, 1999), it is sixty-two years since I first encountered fine bookbinding at a serious level at the Central School of Arts and Crafts, and I have many memories and mixed emotions. All of

*Fig. 28.* Outside Buckingham Palace after my Investiture in 1986.
My wife, Dora, is on the right, with Dr. Marianne Tidcombe.

my teachers and most of my former colleagues, friends and acquaintances have died or disappeared and the craft itself has changed out of recognition since I came into it. Much has changed for the better, such as the improvement in the quality of materials, the fairly widespread adoption of more satisfactory structural methods and, of course, there has been an explosion of creativity in design. However, the last two factors have not been evident in trade practice. On the other hand, some things which were to be admired such as supreme levels of skill and efficiency have been lost[33], probably forever.

It is generally accepted, I think, that bookbinding as a craft is rather special, in that it is extremely demanding and seemingly has infinite subtleties; it is not an end in itself, but is built on to books (one of the most, if not *the* most, important cultural artefacts of mankind) which it preserves and complements, so I feel more fortunate than I can express that I became involved. With a somewhat better school record I might easily have gone into a dull clerical post with poor prospects. As it is, I have done a job which has tangible and, I hope, worthwhile results. I have handled a vast number of wonderful books and I have been able to travel, professionally, and make friends in many places. Also, books have enabled me to meet people in all strata of society and on a more congenial basis—as, for example, when Dora and I were house guests of one of Britain's oldest aristocratic families—than would have been possible, perhaps, if I had been working as an artisan in many another field.

About ten years ago I was the house guest of the Dean of Lichfield Cathedral and his wife in the very large and gracious eighteenth-century Deanery. At the time I was commissioned to produce a designed binding for the Lichfield Cathedral Appeal manuscript. The occasion provided me with very pleasant experiences which included certain privileges such as my sitting with the Dean in the Choir at Evensong and his bringing me early morning tea in my vast bedroom. This may well seem a trifling event to the sophisticated reader, but it has some significance for me as I think back to 1938 and my first day, as an ignorant, immature thirteen and a half year old boy, at the Central School.

I am fascinated by connections with the past, so about six years ago, at a reception held at the Museum of Leathercraft, Northampton, I was intrigued when I was introduced to Sir Hereward Wake, a direct descendant, so he assured me, of Hereward the Wake, a Lincolnshire squire who fought against William the Conqueror in the eleventh century.

Since the first edition of this book was printed and published by Henry Morris in 1995, my life has changed and is about to change again. On August 2, 1997, my wife, Dora, died at the age of seventy-five. She had for some years suffered from the debilitating effects of arthritis of the hips, and the onset of Alzheimer's disease had been apparent for about two years. Then, within a few months of her death, she rapidly went downhill with dramatic loss of weight and was found to be suffering from cancer of the lungs, liver and stomach. She died in St. Thomas's Hospital. After a few months, I sent the last two aged cats to live out their final days in well-run catteries in the country, but to compensate I have taken in a black kitten, Caxton. I now live alone, but have the domestic support of two excellent women who not only 'do' for me, but are also friends: Christine cleans the house and looks after my laundry, and Roberta does my weekly shopping and keeps the garden in good order. I also have the invaluable immediate support and friendship of Flora Ginn and Marianne Tidcombe and many colleagues and friends in Britain and abroad.

The next major event, about which I have ambivalent feelings, will the transfer of my reference library (see pp. 74) to Rochester Institute of Technology in January, 2000, in accordance with a contract signed in 1983. I shall be left with several dozen empty shelves, so I may be reduced to the much derided practice of buying books by the yard! As a result of my being bereft of reference material, I shall in future write very little and I shall not be able to dispense much information to those who require it[34]. I am seventy-five, and with the loss of my wife, the cats and the books, together with a lessening of motivation to grapple with problematic antiquarian books, it may be an appropriate time to slow down and be very selective about the work I accept. I would then hope to do the things I have not previously had much time to do, such as reading (principally maritime, social history and biography), visiting obscure museums and the more charming parts of Britain. I have made a start by joining the Local History Group of the Clapham Society. Perhaps, too, I shall be able to produce designed bindings for which I have about ten commissions. Yielding to pressure from computer-literate friends, I have acquired a machine (an iMac) which I now have to learn to operate, no easy task for this technophobe.

In prospect is an international bookbinding conference—Bookbinding 2000—which will be held in R.I.T. early in June 2000, to mark the installation of my books in their new home. It promises to be the largest

and most important event of its kind yet held, with the Institute's formidable technical resources brought to bear and with three hundred participants and several exhibitions of books and fine bindings. Together with the publication of these *Recollections* it will be an exciting and compensatory period for me at a time which may be close to the end of my career.

All in all, despite somewhat enervating shyness and a chronic tendency to mild depression, I have enjoyed my life and I feel that I have been extremely fortunate in many ways—not least in my friends and associates. My hope is that, in this quickly changing world with its rapid advance in knowledge, I have done more good than harm to an important part of our cultural heritage.

ROYAL COLLEGE OF ART

# H.R.H. Prince Charles'
## Christening Presents

*H.R.H. Princess Elizabeth*
DUCHESS OF EDINBURGH

graciously received these christening presents

from the Royal College of Art on the 13th March 1951

on behalf of H.R.H. Prince Charles

THE BED *was designed by* FRANK GUILLE

THE SILVER ENAMEL ESCUTCHEONS *by* PHILIP POPHAM

THE BEDSPREAD *by* FRANK HOSWELL

THE CHINA *by* PETER WALL

THE SPOON, KNIFE AND FORK *by* ROBERT CLARK

*with* PETER CAVE *who was responsible for*

THE PORCELAIN HANDLES.

THE CASE *was made by* MR. B. C. MIDDLETON

# END NOTES

1. She bore a strong resemblance to Queen Mary and dressed like her with a similar toque, and so on, and she was highly gratified when people bowed and curtsied.
2. A fracture of the humerus caused me to miss the 11-plus examination, and I was not given another opportunity to sit for it, but this was not a great deprivation because I would not have passed it and gone on to grammar school.
3. We had swimming lessons at Marshall Street Baths, Soho, and our playing-fields were in Walthamstow. Occasionally, we were taken to the Victoria and Albert Museum to sketch.
4. McLeish also taught Matthews and my father in the same room more than twenty-five years earlier.
5. Howard Nixon, Assistant Keeper of Printed Books, and bookbinding historian, used to write out binding orders and was frequently seen in the Bindery where I think I first saw him in 1940 before he joined the Army. It was a matter for comment among the binders that he must have a very extensive wardrobe because he seemed to wear a different suit every time we saw him.
6. Fine binding is a very labour-intensive craft and involves the use of costly materials, so the end-product is necessarily expensive; it follows, therefore, that if time is expended unnecessarily, bindings will be beyond the reach of many potential customers. The prices currently charged for mediocre work are often outrageous.
7. He loved to take up a book he had bound and turn it inside out and swing it around by its boards to demonstrate the flexibility of the spine structure.
8. I wrote a detailed article about this in *The British & Colonial Printer*, Aug. 10, 1951.
9. With F.C. Gould. The method is described in my *A History of English Craft Bookbinding Technique*, pp. 12–13.

10. I think his greatest *bête noire* in modern fine binding was the not unusual practice of decorating just the front cover like a one-dimensional artefact, or picture. Time and again he espoused the desirability of unity between all parts of the binding.

11. During the Christmas period, in the interval between jobs, Dora and I spent a few days with Roger and Rita Powell at The Slade, their home in Froxfield, Hampshire. I did some work in the bindery and typed out Roger's draft of his biography of Douglas Cockerell, commissioned for *The Dictionary of National Biography*. There was a party which involved games. I recall sitting next to Edward Barnsley, C.B.E., the celebrated cabinet-maker, and that we both were embarrassed.

12. A very good history of the firm has been written by Frank Broomhead: *The Zaehnsdorfs (1842–1947)* (Private Libraries Assoc., 1986).

13. Their archives contain diverting albums entitled *How Not to Spell Zaehns-dorf*. They have in them a great many envelopes with a vast range of mis-spellings.

14. 36 Catherine Street. The site is now occupied by part of the Strand Theatre.

15. His directorship of a well-known flour company proved to be useful when, during the period of continued wartime rationing, we ran short of that commodity for paste-making.

16. Occasionally I briefly met the distinguished archaeologist Sir Mortimer Wheeler, and was friends with his secretary. Others in whose presence I was youthfully star-struck were Jacuetta Hawkes, who later married J.B. Priestley, and Prof. V. Gordon Childe.

17. Many of Harrison's methods are now commonplace in conservation circles, but they were ground-breaking in his day.

18. When modern repair leather is exposed along joints it sometimes contrasts in its smoothness with the texture of adjacent old leather. If the contrast is serious, I may use a camouflage of old leather scrapings, which is very effective, but if not, the heated straight-grain pallet used parallel with the joints breaks up the smoothness and simulates the creasing which occurs when leather is repeatedly flexed.

19. This is a difficult situation for me because although I do not wish to deceive, if my work is not good enough to do that, which is usually the case, I feel that I shall be regarded as second-rate.

20. Co-founder, many years later, of Bloomsbury Book Auctions.

21. A thick and strong Japanese paper with a mottled look-through, much used around the end of the nineteenth century for fine, limited editions.

22. Arthur Johnson has reminded me that three of us had to transport bindings from his home in Clifford Road to Barnet Public Library for an exhibition by means of a pram which we pushed through the streets.

23. At least I *think* I was elected and not just a guest. On the first occasion, when I was Pollard's guest, there was a slightly embarrassing discussion at table as to whether people in trade should be elected. Pollard maintained that interest in the subject was more important than how one made one's money. On that occasion, Dorothy Miner's name came up for consideration, but it was decided to see how her major exhibition catalogue, *The History of Bookbinding, 525–1950 A.D.* (Baltimore Art Gallery, 1957) turned out.

24. Son of J.H. Mason (see p. 6).

25. Early in the 1960s, a two-day meeting was arranged for City & Guilds people, Chief Examiners and teachers, in Wolverhampton. I had with me the finalized question papers for the forthcoming examinations, and it was not until I was on my way home on the train that I realized that I had left them in their envelope on a table. It was a bad moment and I had to get off the train at the next stop and phone back to have them found and made secure. Fortunately, they had not been disturbed, but if security had been breached a great deal of work would have been wasted and the examinations would have needed to be postponed.

26. At this time I was still a member of the National Union of Printing, Bookbinding and Paper Workers which I had been required to join when I was employed at the B.M. Bindery. When Horne arrived I was required by the Union to pay him the full journeyman rate, even though he was a novice. This was unrealistic, so I resigned. When he was proficient, I paid him well above the going rate.

27. Elected to membership of the Guild of Contemporary Bookbinders in 1956.

28. They go through seven sequences of signature marks plus a few more, so there must be about 175 sections.

29. He was for many years manager of the Department of Extra Binding at R.R. Donnelley & Sons Company, which was given commissions of great importance, and he held many consultative posts.

30. Maureen Duke also went on a number of occasions and did valuable work.

31. Founded at the beginning of the nineteenth century, the firm was extremely well known for its shoe-blacking products—spirit stains came later. Unfortunately, they foundered in the 1980s during the recession, as did a great many other old-established companies. A long and detailed account of the firm, "A Day at 'Day and Martin's' " is in George Dodd's *Days at the Factories* (London, 1843), pp. 208–30.

32. Or the Prince of Wales, in her absence abroad.

33. I have written about the evolution of English craft bookbinding since the Second World War, including the decline of the apprenticeship system and the subsequent introduction of two-year college courses, in my *A History of English Craft Bookbinding Technique* (Oak Knoll Press and The British Library, 4th ed., 1996), pp. 299–310.

34. I have received many letters with requests for information, which is fine, but I have also had telephone calls from far and wide with questions about obscure points which often require more mental agility than I can muster, especially when 'the sun is over the yardarm'!

*Book label. Engraved in wood by*
*Leo Wyatt in the 1970s. Printed in*
*brick-red, green and blue.*

*Mr. Middleton's bindings have been signed*
*with this monogram tool for 50 years.*

*Trade card used circa 1953.*

# Descriptions for the Following Colour Illustrations

I have produced in the region of one hundred modern designed bindings, the majority of which are reproduced here in colour, followed by thirty-four monochrome illustrations. Where possible, I have acknowledged permission to reproduce, but in many cases ownership is unknown to me.

My designs, such as they are, span more than half a century, and my approach is summed up in my standard statement:

> As a book restorer I am primarily a craftsman who incidentally produces simple designs for the embellishment of occasional fine bindings rather than a trained designer who binds books for the purpose of giving expression and permanent form to his creative ideas. In common with other designer-binders my aim is to produce a sound structure with the most durable materials available. My designs are intended to please the eye, not engage the intellect, principally by the employment of textures, strongly defined shapes and contrasts, and by the play of light on gold, preferably in combination and in a manner which complement the book.

There has been no significant or interesting progression in my designs, so I have not felt the need to arrange the illustrations in chronological order. My hope is that my interest in gold-tooling, a technique which is at present out of fashion among non-trade binders, is apparent and will give some pleasure.

*Colour illustrations*

1.  *Rudyard Kipling's Verse*. Orange goatskin. Tooled in gold and black. Bound in 1943. My first designed binding, produced (outside the examination room) as a completed specimen binding for a City & Guilds examination.

2.  Arthur Mee. *London*. Blue goatskin with white parchment and red leather onlays. Tooled in gold. Bound in 1947.

3.  *The Treasury of the Sacred Heart*. Green goatskin, with mother-of-pearl panels set into recesses in the outer covers. The photograph shows brown goatskin doublures. Tooled in gold and black. Bound in 1950 as a gift for Dora who, at the time, was a practising Roman Catholic.

4.  G. Elliot Anstruther. *The Bindings of Tomorrow.* Burgundy goatskin. Tooled in gold and black. Bound in 1950. Courtesy: The Cary Collection, Rochester Institute of Technology, Rochester, NY.

5.  H. J. Plenderleith. *The Conservation of Antiquities and Works of Art.* Red goatskin. Tooled in gold and black. Bound in 1958.

6.  T. B. Reed. *A History of the Old English Letter Foundries*. Bound in bright red goatskin with black inlays, doublures and flyleaves. Tooled in gold and blind. Bound in 1957. Courtesy: The Trustees of the Victoria & Albert Museum.

7.  David Bland. *A History of Book Illustration*. Light-blue goatskin inlaid with grey, brown, red and yellow. Tooled in gold and black. Bound in 1975. Courtesy: The National Library of Wales.

8.  *The Oxford Lectern Bible* (1935) designed by Bruce Rogers. Red goatskin with black inlays, doublures and flyleaves. Tooled in gold and blind. Bound in 1973. Courtesy: The Grabhorn Collection on the History of Printing and the Development of the Book, San Francisco Public Library.

9.  Details unknown.

10. Seamus Heaney. *Bog Poems*. Dark-brown goatskin inlaid with yellow. Tooled in gold and black. Bound in 1983.

11. Bernard C. Middleton. *A History of English Craft Bookbinding Technique*. Black goatskin inlaid with green and onlaid with red. Tooled in gold and black. Bound in 1987. Courtesy: Elizabeth Greenhill.

12. *The Whittington Press: A Bibliography, 1971–1981*. Red-brown goatskin inlaid with jade-green and onlaid with light brown and black strips.

13. Charles C. Oman and Jean Hamilton. *Wallpapers*. Light-brown goatskin with green, purple, red and black inlays and onlays. Tooled in gold and black. Bound in 1989. Courtesy Anthony Dowd.

14. Bernard C. Middleton. *A History of English Craft Bookbinding Technique*. Light-brown goatskin inlaid with dark brown and black. Tooled in gold and black. Bound in 1977.

15. Alan G. Thomas. *Great Books and Book Collectors*. Black goatskin with bright-red inlays. Tooled in gold and black. Bound in 1977. Courtesy: J. V. Lunzer.

16. John Sparrow (Ed.). *Lapidaria Octava*. Dark-green goatskin inlaid with brick-red and onlaid with jade-green. Bound in 1988.

17. Henry Morris. *Two Birds With One Stone*. Black goatskin inlaid with yellow and onlaid with bright-red. Bound in 1995. Courtesy: Henry Morris, Newtown, PA.

18. *The Times Atlas of the Oceans*. Dark-blue goatskin with light-blue (in circular recess) and bright-red onlaid. Bound in 1987. Private collection.

19. Bernard C. Middleton. *A History of English Craft Bookbinding Technique*. Mid-brown goatskin onlaid with dark-brown and jade-green. Tooled in gold and black. Bound in 1987.

20. *Virgil's Georgics.* Yellow goatskin with dark-brown inlaid in circular recess and small onlays of jade-green and bright-red. Tooled in gold and black. Bound in 1987.

21. Dard Hunter. *Papermaking by Hand in America.* Mid-brown goatskin onlaid with dark-brown. Tooled in gold and black. Bound in 1983.

22. Dudin. *The Art of the Bookbinder and Gilder.* Light-brown goatskin with black onlay on the spine, black inlays on the boards and green onlaid strips. Tooled in gold and black. Bound in 1979. Courtesy: Mel Kavin, Pico Rivera, CA.

23. *Bibliography of the Grabhorn Press, 1915–1940.* Black goatskin with yellow inlaid in recess and bright-red strips onlaid. Tooled in gold and blind. Bound in 1987.

24. Marianne Tidcombe. *The Bookbindings of T. J. Cobden-Sanderson.* Citron goatskin with dark green set into recess. Tooled in gold and black. Bound in 1986.

25. Robin Myers. *The Stationers' Company Archive, 1554–1984.* Mid-brown goatskin inlaid with black and onlaid with red and green. Tooled in gold and black. Bound in 1990. Courtesy: Ms. Robin Myers.

26. *Lichfield Cathedral Appeal 1986–1989* Ms. (1990). Mid-brown goatskin onlaid with jade-green and purple. Tooled in gold and blind. Bound in 1990. Courtesy: The Dean and Chapter, Lichfield Cathedral.

27. Howard M. Nixon. *Broxbourne Library: Styles and Designs of Bookbinding.* Mid-brown goatskin inlaid with black and onlaid with jade-green. Tooled in gold and black. Bound in 1984. Courtesy: Fred A. Jordan, Livonia, NY.

28. *The Engravings of Eric Gill.* Bright-red goatskin with green onlays. Tooled in gold and black. Bound in 1989. Courtesy: Mel Kavin, Pico Rivera, CA.

29.   Jean-Luc Daval. *History of Abstract Painting*. Black goatskin onlaid with royal-blue. Tooled in gold and blind. Bound in 1990.

30.   *Four Gospels*, illustrated by Eric Gill and printed on vellum. Brown goatskin. Tooled in gold. Bound in 1980. Courtesy: Sir Paul Getty, K.B.E.—Wormsley Library.

31.   Sigfred Taubert. *Bibliopola*. 2 vols. Red-brown goatskin inlaid with jade-green and yellow. Tooled in gold and black. Bound in 1985. Courtesy: J. D. Goodwin.

32.   *The Officina Bodoni: The First Six Years*. Black goatskin inlaid with yellow. Tooled in gold and black. Bound in 1983. Courtesy: Sir Paul Getty, K.B.E.—Wormsley Library.

33.   Dorothy Miner. *The History of Bookbinding, 525–1950 A.D.* Jade-green goatskin onlaid with bright-red and black. Tooled in gold and black. Bound in 1983. Courtesy: Sir Paul Getty, K.B.E.—Wormsley Library.

34.   Anthony Hobson. *Great Libraries*. Dark-green goatskin. Tooled in gold and blind. Bound in 1973.

35.   Stanley Morison and Kenneth Day. *The Typographic Book, 1450–1935*. Black goatskin inlaid with grey and onlaid with bright-red. Background blocked in blind with facsimile of an early printed page. Tooled in gold. Bound in 1973.

36.   John W. Waterer. *Leather in Life, Art and Industry*. Yellow goatskin inlaid with black and onlaid with red and green. Tooled in gold and black. Bound in 1994. Courtesy: The Museum of Leathercraft, Northampton, England.

37.   Dard Hunter. *Old Papermaking*. Dark-blue goatskin with white tawed pigskin (deeply blind-blocked with watermark symbols) set into recessed panels. Tooled in gold. Bound in 1977.

38.   Ashendene Press *Bibliography, 1895–1935*. Brick-red native-dyed niger inlaid with yellow and jade-green, and onlaid with narrow black strips. Tooled in gold and blind. Bound in 1989.

39. *Bibliography of the Grabhorn Press, 1915–1940.* Black goatskin inlaid with blue-green and natural calf, and onlaid with bright-red. Tooled in gold and black. The calfskin panel is blind-blocked and reproduces a page from a Grabhorn book. Two other volumes of the *Bibliography* were bound for the same collector (James L. Thielman) but with different colour combinations. Bound in 1980.

40. Dante. *La Divina Commedia or the Divine Vision of Dante Alighieri.* Black and red goatskin onlaid with yellow (in circular recess) and red. Tooled in gold and blind. Bound in 1987. Courtesy: Dr. John D. F. Tarr, Pasadena, CA.

41. Bernard C. Middleton. *A History of English Craft Bookbinding Technique.* Black goatskin inlaid with yellow and onlaid with jade-green. Tooled in gold and black. Bound in 1987.

42. Marianne Tidcombe. *The Doves Bindery.* Black goatskin inlaid and onlaid with yellow with red set into a recess. Tooled in gold and black.

43. Marianne Tidcombe. *The Bookbindings of T. J. Cobden-Sanderson.* Light-brown goatskin inlaid with black or dark-green and onlaid with red. Tooled in gold and black. Date unknown.

44. James Joyce. *Anna Livia Plurabelle.* Dark-blue goatskin onlaid with bright-red. Tooled in gold and black. Bound in 1982. Courtesy: John Keatley.

45. Samuel Ellenport. *The Development & Usage of Brass Plate Dies.* Black goatskin inlaid with yellow and onlaid with red. Blind-blocked dark-green calf in central recess. Tooled in gold and black. Bound in 1983. Courtesy: Dr. Thomas S. Evans, MD, Pittsburgh, PA.

46. *The Origin of Christopher Columbus.* Dark-blue goatskin with red set into central recess. Tooled in gold. Bound c. 1992.

1 2

3

4 5

*Plate 1*

6  7

8  9

10  11

Plate 2

12  13

14  15

16  17

*Plate 3*

18 19

20 21

22 23

Plate 4

24  25

26  27

28  29

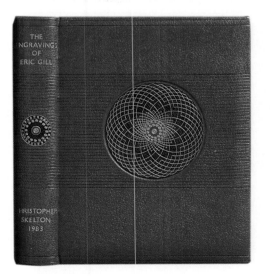

Plate 5

31

30  32

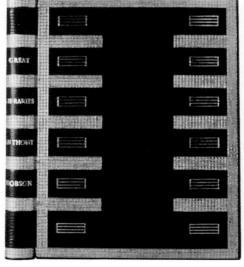

33  34

*Plate 6*

35  36

37  38

39  40

*Plate 7*

41 42

43 44

45 46

*Plate 8*

47. *The Nonesuch Century*. Dark red goatskin with undyed calfskin sou-blures and flyleaves. Tooled in gold and blind. Bound in 1954.

48. Simon and Rodenberg. *Printing of Today*. Brown goatskin. Tooled in gold and blind. Bound in 1956.

49. John Farleigh. *The Creative Craftsman*. Bright red goatskin with black goatskin doublures and flyleaves. Tooled in gold and black. Bound c. 1952. By permission of the British Library Board.

50. Christian Barman. *The Bridge*. Dark red goatskin. Tooled in gold and black. Bound in 1951.

51. *Book of Common Prayer*. Mauve goatskin, with cross onlaid with yellow. Tooled in gold and blind. Bound c. 1965.

52. Claude Roger-Mark. *French Original Engravings*. Bright red goatskin with black goatskin doublures and flyleaves. Tooled in gold and black. Bound in 1956.

53. *The Kings Town Award*. Brown goatskin with green central inlay. tooled in gold and blind. Bound in 1958.

54. Hugh Williamson. *Methods of Book Design*. Bright red goatskin. Tooled in gold and black. Bound c. 1958. Courtesy: Bodleian Library, University of Oxford.

55. *The Nonesuch Century*. Red goatskin. Tooled in gold and black. Bound in 1954.

56. Simon and Rodenberg. *Printing of Today*. Black goatskin. Tooled in gold and blind. Bound in 1953. Courtesy: Bodleian Library, University of Oxford.

57. Howard M. Nixon. *Broxbourne Library: Styles and Designs of Bookbindings*. Blue goatskin with putty-coloured goatskin doublures and flyleaves. Tooled in gold and blind. Bound in 1960. Courtesy: John Ehrman.

58. David Bland. *A History of Book Illustration*. Bright green goatskin with gold and black tooling. Bound in 1962.

59. *Moxon's Mechanick Exercises on the Whole Art of Printing (1683–4)* (1962). Dark brown goatskin with light brown calfskin in recessed panel. Tooled in gold and black. Bound in 1967.

60. Howard M. Nixon. *Twelve Books*. Bright red goatskin with black inlays and green central onlay. Black goatskin doublures and flyleaves. Tooled in gold and black. Bound in 1964. By permission of the British Library Board.

61. R. Furneaux Jordan. *European Architecture in Colour*. Light brown goatskin with black doublures and flyleaves. Tooled in gold and blind. Bound in 1962.

62. Speltz. *The Styles of Ornament*. Orange goatskin, unornamented. Green goatskin doublures tooled in gold. Bound in 1952.

63. Carl J. Weber. *A Thousand and One Fore-Edge Paintings*. Blue goatskin with putty-coloured doublures and flyleaves. Tooled in gold. Fore-edge painting by Stevens. Bound in 1955.

64. John Lewis. *Printed Ephemera*. Grey goatskin with coloured inlays. Lettered in gold. Bound in 1968. Courtesy: H. M. Fletcher.

65. Bernard C. Middleton. *A History of English Craft Bookbinding Technique*. Brick-red goatskin. Tooled in gold and black. Bound in 1969. Courtesy: H. M. Fletcher.

66. Fiona MacCarthy. *All Things Bright and Beautiful*. Light blue goatskin with dark blue band inlaid across the spine and boards. Tooled in gold. Bound in 1973. Private collection.

67. Octave Uzanne. *L'Art dans la Décoration Extérieure des Livres.* Bright red goatskin tooled in gold and black. Bound in 1956. Courtesy: The Cary Collection, Rochester Institute of Technology, Rochester, NY.

68. Dard Hunter. *Papermaking.* Red goatskin. Tooled in gold. Bound c. 1961.

69. Horace Hart. *Notes on a Century of Typography at the University Press, Oxford, 1693–1794.* White pigskin with violet goatskin onlays and violet suede doublures. Tooled in gold. Bound in 1977.

70. Andrade. *Love Life of the Birds.* Three copies bound in red, green and blue goatskin. Tooled in gold and blind. Bound in 1970.

71. *The Complete Encyclopaedia of Antiques.* Turquoise blue goatskin with inlays and lettering-pieces of light brown goatskin. Tooled in gold and blind. Bound in 1963.

72. C. H. V. Sutherland. *Gold.* Black goatskin with strips of red laid between raised bands on sides. Tooled in gold and black. Bound in 1970.

73. *Visitors' Book.* Blue goatskin. Tooled in gold and blind. Bound c. 1960.

74. *The Little Passion* with Albrecht Durer's woodcuts (1971). White pigskin with violet calfskin laid into recessed panels. Blocked in gold. Bound in 1975.

75. Bernard C. Middleton. *A History of English Craft Bookbinding Technique.* Light red goatskin. Tooled in gold and black. Bound in 1969.

76. David Bland. *A History of Book Illustration.* Black goatskin with strips of red laid between raised bands on sides. Tooled in gold and black. Bound in 1970.

77. Owen Jones. *The Grammar of Ornament*. Light blue goatskin. Tooled in gold and black. Bound in 1951. Courtesy: Sir Paul Getty, K.B.E.—Wormsley Library.

78. *Roxburghe Club: Forty Years*. Black and grey goatskin with coloured inlays. Tooled in black. Bound in 1971.

79. Bernard C. Middleton. *A History of English Craft Bookbinding Technique*. Black goatskin inlaid with yellow. Tooled in gold and black. Bound in 1985. Courtesy: J. D. Goodwin.

80. *The Atlas of the Universe*. Dark blue goatskin. Tooled in gold. Central grey 'button' tooled in palladium. Bound in 1971. Private collection.

47 48

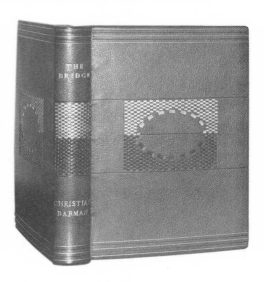

49 50

51 52

53      54

55      56

57          58

59          60

61 62

63 64

65       66

67       68

69          70

71          72

73      74

75      76

77          78

79          80

# APPENDICES

**This Indenture** made the *third* day of *February* one thousand nine hundred and *forty-one* , between*

* The Apprentice. *Bernard Chester Middleton*

(being of the age of *sixteen* years) hereinafter called " the Apprentice " of the first part,

of *Regent Marcus Geoffrey Middleton*

(the† *Father* of the said

† Father, Guardian, or next Friend.

‡ Principal Officer of the Works, to be described by his Name and Office.

*Bernard Chester Middleton* ), of the second part, and‡

*Walter James Thomas Archer, General Manager, H. M. Stationery Office Press*

who with his successors in his said office or other the person appointed from time to time to perform the duties of his said office, is hereinafter called " the Master " (for and on behalf of the King's most Excellent Majesty, His Heirs and Successors), of the third part, WITNESSETH that in consideration of the covenants and agreements of the Master hereinafter contained, the Apprentice (with the consent and approbation of the said party of the second part, testified by his being a party hereto), Doth by these presents, freely and voluntarily put and place himself Apprentice to the Master to learn and exercise the art or occupation of *Bookbinder* in the several branches or departments thereof in which Apprentices are, or shall or may be employed in His Majesty's Stationery Office Printing Works at *the British Museum*, or other places, as may at any time or times during the term of his Apprenticeship be directed by the Controller of His Majesty's Stationery Office, to serve as an Apprentice with and under the Master for the use and benefit of His said Majesty, His Heirs and Successors, for, and during and unto the end of the full term of ⊙ *five* years to be computed from the *twenty-ninth* day of *October* , one thousand nine hundred and *forty* , to the *twenty-eighth* day of *October* , one thousand nine hundred and *forty-five*.

And the Apprentice and the party of the second part do severally hereby covenant with the Master that he the said Apprentice shall and will during the said term faithfully and industriously serve the Master, and also such persons as he the said Apprentice may be placed under by the Master, and obey all their respective lawful commands, orders, and directions, and will observe all rules and regulations which are or shall be from time to time made by the said

T.L. 318/19.

⊙ *Having regard to two years' training as a Bookbinder at the School of Arts and Crafts, Southampton Row, London, W.C.*

2

Controller in respect of Apprentices, and generally will diligently conduct himself, and use his best abilities and endeavours towards his improvement and perfection in the said art or occupation of *Book-binder* , and for the good and benefit of His said Majesty, His Heirs and Successors therein. And also that he the said Apprentice shall not and will not at any time during the said term do, or willingly suffer to be done, any act or thing whatsoever whereby the goods and effects of His said Majesty, His Heirs and Successors, can, shall, or may in any wise be embezzled, injured, or damaged, or His officers or service defrauded, or otherwise prejudiced in any manner howsoever, nor shall, nor will, at any time absent himself from the service or work without the leave of the Master or any Officers under whose authority he may be placed ; nor contract marriage during the period of this Indenture ; nor be guilty by word or action of any immoral, indecent, irregular, or improper conduct or behaviour in any respect whatsoever, but shall and will demean himself at all times with strict propriety and submission to his superiors.

And the party of the second part doth hereby covenant with the Master that he, the said party of the second part, can and will from time to time during the said term find and provide for the Apprentice good and sufficient board, lodging, clothing, and washing, and all other necessaries proper for his personal accommodation and benefit suitable to his said intended situation. And also provide such implements, working tools, and instruments as the customs of the trade require to enable him to learn and practice the said art or occupation of *Book-binder*

And in consideration of all and singular the premises the Master doth hereby (for and on behalf of His said Majesty, His Heirs and Successors) covenant with the Apprentice and the party of the second part, and each of them, that he the said Apprentice duly observing, performing, and keeping all the covenants and agreements on his part hereinbefore contained shall be properly taught and fully instructed in the said art or occupation of *Book-binder* And shall during such time as he shall continue at his work be entitled to and receive the wages following, that is to say :—

| | | |
|---|---|---|
| During the first year of the said term the sum of | *20/-* | per week ; |
| During the second year of the said term the sum of | *26/8* | per week ; |
| During the third year of the said term the sum of | *32/-* | per week ; |
| During the fourth year of the said term the sum of | *38/6* | per week ; |
| During the fifth year of the said term the sum of | *44/-* | per week ; |
| ~~During the sixth year of the said term the sum of~~ | | ~~per week~~ ; |
| ~~And during the seventh year of the said term the sum of~~ | | ~~per week.~~ |

And lastly, it is hereby especially stipulated and agreed by and between the said parties hereto, that in case the said Apprentice shall for the space of one week during the said term (unless disabled from work by sickness) absent himself from his service and employment under this Indenture, without the license and consent of the Master or other person authorised in that behalf, or shall neglect to perform the reasonable and necessary work required from him, or shall be guilty of embezzlement or other criminal conduct, or shall for a

3

period of six consecutive calendar months be disabled from work by sickness, or shall suffer from any disease or complaint that would render his continued employment dangerous to himself or his fellow employés, it shall be lawful for the Master to declare this Indenture to be void by notice in writing, signed by the Master, and left at the usual or last place of abode of the party of the second part, or if he be dead, or cannot be found, by exhibiting the said notice publicly in the Printing Works, and thereupon this Indenture shall be void accordingly.

In witness whereof the parties to these presents have hereunto subscribed their names, and affixed their seals the day and year first above written.

*Signed, Sealed, and Delivered by*
*all the parties (being first duly*
*stamped) in the presence of*

_David Evans_____Witness.

_Bernard Chester Middleton._

_Regent Marcus Geoffry Middleton_

_Walter James Thomas Archer_

I certify that Bernard Chester Middleton has duly completed his apprenticeship as Bookbinder as set out in the indenture herein.

_____
Director of Printing Works.

H.M. Stationery Office,
   429 Oxford Street, W.1.

London School of Printing and Kindred Trades

6 Stamford Street, London, S.E.1

SESSION 1942-3

Report for Easter Term, 1943

```
H.M. Stationery Office.
421. Oxford Street,
W. 1.
```

Student **Middleton, B.C.**          No. **67**

Subject **Binding.**          Half Day **Thur. p.m.**

Attendances *15* out of a possible *15*

Times late

|  |  | CLASS AVERAGE |
|---|---|---|
| Marks for Homework (Dec.-Jan.) | *85* % | *71* % |
| „ „ „ (February) | *94* % | *84* % |

Practical Work *Of a high standard.*

Conduct *Excellent.*

Remarks *Always giving of his best.*

Instructor *C. Gillett.*

*The new term will commence on Monday, 3rd May, 1943*

# City and Guilds of London Institute

## DEPARTMENT OF TECHNOLOGY

## 1943

### 108.—BOOKBINDING

### Section A.—Forwarding.

### Final Examination.—Written Paper.

**Tuesday, May 4th, 7 to 10 p.m.**

*Read each question carefully ; many marks are lost by misreading questions.*

*The maximum number of marks obtainable is affixed to each question.*

*An alternative dealing with account book binding is given with each of the first four questions.*

*EIGHT questions should be attempted ; a candidate must not answer both of the questions when an alternative is given, but may choose which he pleases. Drawing instruments may be used.*

**1.** Submit a sketch of the back of a one inch crown 8vo book marked up for sewing on five cords " sawn in " ; name the thickness of sewing cord you would use and describe briefly the preparation and operation of sewing. *(15 marks.)*

**1.** (A) *Alternative.*—Describe briefly the preparation and operation of sewing a six-quire foolscap folio account book which is to be bound in rough calf. *(15 marks.)*

**2.** Describe briefly the types of boards you would choose for binding a demy 8vo book in the following styles, and the method of preparation and cutting to size of each :—(a) Whole morocco " in board " style ; (b) whole calf " out board " style ; (c) quarter pigskin " split boards " ; (d) whole cloth. *(15 marks.)*

**2.** (A) *Alternative.*—Give briefly some information about papers which are suitable for the making of account books. *(15 marks.)*

[SEE OVER]

2                           BOOKBINDING.

**3.** Describe briefly the binding, exclusive of finishing, of a full calf royal 4to thin Music book, with marble paper ends and sprinkled edges.                                          *(20 marks.)*

**3.** (*A*) *Alternative.*—Describe briefly the binding, exclusive of finishing, of a whole Basil 100-page royal 4to Memorandum book with marble paper ends and sprinkled edges, the book to be bound in " account book " style.                     *(20 marks.)*

**4.** Estimate the time only, not the cost, required for each process and the amount of each material required, for the binding of 25 books as specified in question 3.            *(12 marks.)*

**4.** (*A*) *Alternative.*—Estimate the time only, not the cost, required for each process and the amount of each material required for the binding of 25 books as specified in question 3 (A) Alternative.
                                                    *(12 marks.)*

**5.** Outline the principal differences between Letterpress and Account book binding.                         *(12 marks.)*

**6.** With what styles of binding would you paste or glue the end papers down and close the boards immediately and with what styles would you leave them open to dry ?          *(7 marks.)*

**7.** Give briefly some information about map mounting.   *(7 marks.)*

**8.** Describe briefly three methods of " lining up " the back of a demy 8vo book and state the binding for which each method is suitable.                                       *(12 marks.)*

*The Final Practical Examination in* FORWARDING *will be held on* **Friday, May 14th** *(4 hours), and on* **Saturday, May 15th** *(4 hours).*

*Each candidate's work at the Practical Examination must be clearly marked with his examination number as on the card used at the Written Examination.*

# City and Guilds of London Institute

## DEPARTMENT OF TECHNOLOGY

## 1943

### 108.—BOOKBINDING

### Section A.—Forwarding.

### Final Examination.—Practical Test.

Friday, May 14th (4 hours) ; and Saturday, May 15th (4 hours).

Two books in quires, folded and pressed, and paper for ends, are given to you.

Prepare them for binding, one in full morocco and the other in half calf.

The former is to be sewn on five cords flexible, zig-zag ends, edges cut smooth and left plain.   Proceed as far as and including headbanding but not lining up.

The other book is to be sewn on five cords sawn in, stuck on ends, top edge cut smooth and left plain, the other edges uncut.   Get this book into boards, only.

*At the close of the Examination, the work of each candidate, clearly marked with his Examination number as on his card, must be packed and forwarded by* PARCEL POST *to the* CITY AND GUILDS OF LONDON INSTITUTE, 31, BRECHIN PLACE, LONDON, S.W.7.

# CITY AND GUILDS OF LONDON INSTITUTE

INCORPORATED BY ROYAL CHARTER

## DEPARTMENT OF TECHNOLOGY

---

## This is to Certify that

*Bernard Chester Middleton*

passed in the *First* Class the FINAL Examination in

*Bookbinding, Section A (Forwarding),*

in the year 1943, and was awarded *First Prize equal, £ 2.*
*(Skinners' Company) and Institute's Silver Medal.*

*Henry Allan Steward*

Chairman of the Technology Committee.

*W French*

Superintendent, Department of Technology.

*B. C. Middleton.*  { Signature of the holder
{ of this Certificate.

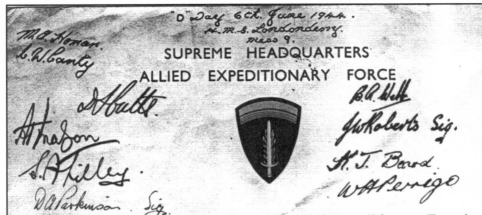

SUPREME HEADQUARTERS
ALLIED EXPEDITIONARY FORCE

Soldiers, Sailors and Airmen of the Allied Expeditionary Force!

You are about to embark upon the Great Crusade, toward
which we have striven these many months. The eyes of
the world are upon you. The hopes and prayers of liberty-
loving people everywhere march with you. In company with
our brave Allies and brothers-in-arms on other Fronts,
you will bring about the destruction of the German war
machine, the elimination of Nazi tyranny over the oppressed
peoples of Europe, and security for ourselves in a free
world.

Your task will not be an easy one. Your enemy is well
trained, well equipped and battle-hardened. He will
fight savagely.

But this is the year 1944! Much has happened since the
Nazi triumphs of 1940-41. The United Nations have in-
flicted upon the Germans great defeats, in open battle,
man-to-man. Our air offensive has seriously reduced
their strength in the air and their capacity to wage
war on the ground. Our Home Fronts have given us an
overwhelming superiority in weapons and munitions of
war, and placed at our disposal great reserves of trained
fighting men. The tide has turned! The free men of the
world are marching together to Victory!

I have full confidence in your courage, devotion to duty
and skill in battle. We will accept nothing less than
full Victory!

Good Luck! And let us all beseech the blessing of Al-
mighty God upon this great and noble undertaking.

# Scale in

# Bookbinding

## by Bernard C. Middleton

who asserts that the craft has wilted under the stranglehold of economic considerations and in this, the first of a new series, maintains that it can recover its vitality *if* . . .

SCALE, as it relates to Bookbinding, is the subject of this Monograph because it plays a very important part in that art and craft and usually receives less than its due regard in text books. It may be defined as the relation of one thing to another, but only to a limited degree is that due and correct relationship appreciated and judged by the layman. Full appreciation can be gained only by long and intimate contact with the materials employed in the craft. This is affirmed at considerable length in the valuable section on Design, in John W. Waterer's *Leather in Life, Art and Industry*. In some fields of Industrial Design only *pleasing* proportion need be aimed at. Other industries, bookbinding among them, need to consider the claims of utilitarian and technical factors, and be modified accordingly to achieve a satisfactory compromise. This can be phrased no better than the Design and Industries Association's slogan— Fitness for Purpose. My present aim, then, is to outline the ideal in book construction, from the point of view of Scale, at the same time indicating whatever modifications are technically desirable.

Throughout the binding of a book almost every operation must depend for its success on two qualities (a) functional, (b) aesthetic. The former is of paramount importance, but during the past three hundred years has been subordinated to the latter. Since the beginning of the 19th century this fine craft, in common with many others, has wilted under the stranglehold of Economic Considerations—what else can have killed so many enlightened spirits, and smothered many a fine potential creation?—but it can recover its vitality *if* there is an understanding of essentials both by binder and customer.

The first thing to which attention must be paid in book production, and it is a factor on which many of the operations of binding will depend for success, is the thickness of the text paper. This quite definitely is of great importance— though few publishers seem to realise it—for however fine and clever the binding it will not function

nicely if the pages do not lie down without persuasion. Thick paper and an inappropriate binding (e.g., "flexible" style) usually results in the familiar and inconvenient fan-like opening. Of equal importance, and as often disregarded, is the matter of grain direction. It is difficult to over emphasise the several reasons for having the grain running up and down the book as opposed to back to fore-edge. Two best reasons are that greater flexibility is allowed, and corrugations across the book, caused by dampness, are obviated. This serves to stress the view that no part of book production should be regarded as something distinct from the rest; nearly everything is to some degree affected by everything else, therefore, regard the book as a whole.

Sewing thread may be cited as an example of the proportion of the unit being obscure in itself, but the opposite in its effect. The main points to be considered in its choice are quite straightforward but too often ill-considered. If the book's component sections are thin and numerous less " swelling " will accrue from the use of thin thread than from thick. Conversely, if the sections are few and thick, thin thread will not provide adequate swelling for the operation of " backing." These considerations are affected to some extent by the nature of the paper being handled. A hard-sized, hot-plated paper will need a thinner thread than will a soft " antique " type into which the thread is liable to be crushed. Inaccurate judgment can be functionally catastrophic, particularly if the thread is too thick, and examples of it are too often to be seen.

The paper used in endpapers should closely approximate to the weight of that on which the text is printed, unless, perhaps, the latter is too heavy. Should the paper be too thin, strength will be unnecessarily sacrificed—the sewing thread may pull through the joint fold, or the leaves may come adrift by tearing. Too thick a paper will result in the end leaves of the book being strained and dragged out of position (this applies more particularly to cloth-cased and cut-flush work

PAPER & PRINT, SUMMER, 1950

where the "ends" are tipped on only) and it often causes the endpapers to become a unit divorced from the rest of the book instead of being an integral part of it. Except for their effect on the book the thickness of endpapers is not very noticeable, consequently they are not always objectively considered from that point of view.

Given a great deal more attention, probably because it is more obvious, is the "round" or "shape" of books, which should be less than the third of a circle usually advocated in text books. The half-circle has a gross appearance, but, more important, a volume so shaped is likely to open badly. A heavily-rounded, hollow-backed book will not readily "throw up" when opened, but when it does it tends to throw up too much, thereby setting up a strain everywhere. Heavily-rounded, tight-backed books will be found difficult to open at all. However, the opposite extreme, too, must be avoided, for a flat, unbacked book soon becomes concave. *ABC* timetables and *Whitaker's* Almanacs are suitable examples. The mechanics of books are more easily observed than described, therefore books of every style and variation should be carefully examined for their workability. Many mistakes and disappointments may be obviated by the examination of other people's work, and it all helps to make one conscious that a great deal more thought should

be put into book construction. It is an unfortunate fact that unbacked or little-backed books open well but tend to fall out of shape and sometimes disintegrate. In the interests of strength, bookbinders must often sacrifice this virtue and others besides. Only in this spirit of compromise can be obtained the best possible result, which to the reader and the connoisseur is the book that opens well, closes well, lasts well, and finally looks well. When that ideal has been achieved—so has skill.

The theme of relating one thing to another is maintained with the choice of boards, which should be determined by the thickness and/or weight of the book in question. As with endpapers, if they are too light they will not adequately protect the volume between them, neither will they support it. Undue heaviness will contribute to the frequently-recurring and tragic anomaly of the book being pulled apart by its "binding."

"Squares" are provided for the purpose of book edge protection; extra large ones serve that purpose with no greater efficiency than those of moderate proportions, but they *do* look very ugly. Heavy boards and large squares combine to make some books very tiresome objects to handle, as every perambulating bibliophile knows! When the squares are too small and the boards are rounded on the edges there is usually found to be insufficient definition of outline between the boards and the book to look pleasant. Bindings of music usually have small squares, but they should not be dispensed with entirely if tearing of the pages at the tail is to be avoided.

Whatever the covering material, it must be chosen for its degree of flexibility and thickness; and the size and weight of the book to be covered must, without exception, be fully considered. But it should be remembered that thinness is not necessarily synonymous with flexibility. Many binders, professional and otherwise, spend much time considering aesthetics, which could with profit be devoted to the finer judgment of the fitness of the material for its purpose. Thick leather often results in boards being "out of joint" (i.e., they hinge at the wrong place) and an inevitable stiff opening will be the lot of he who employs it. In addition, its use results in the term "tight back," implying a sinister meaning that was never intended! It should be superfluous to state that excessive paring of leather unnecessarily impairs its strength; but it is not generally appreciated that when leather is reduced in thickness, the reduction of strength is proportionately greater. This is because the hair-side fibres are shorter, more brittle and less intricately entwined than those of the flesh side which is usually pared.

**Buckram,** being coarse and thick may most advantageously be used on large and heavy books when an expensive binding is not desired.

204

PAPER & PRINT. SUMMER, 1950

Cloth, the qualities and weights of which vary vary considerably, should be chosen with caution. Much of it has less tensile strength than good hand-made paper, and often becomes very limp with a little use. Buckram and cloth, in common with paper, should be used with the grain (of paper) or "warp" (of woven materials) running up the book. This facilitates the easy movement of the boards and prevents them warping to a bad shape.

The height and width of the spinal bands is a subject on which taste greatly varies, and both extremes of which are practised with detrimental effect. In "flexible" work there are two factors to be considered, from the constructional point of view, if the bands are to be large: (a) that the bands are not so large as to restrict the opening of the book; (b) that they are not so large as to necessitate undue and harmful stretching of the cover over them. At the other end of the scale, small and low bands appear weak and straggling, particularly on a fat book, and they will not adequately protect the spine by taking wear and tear. The turn-in of the leather, on the spine, should never be higher than the bands which are situated in between. By paring the leather (where it turns in and lies flat) as thin as possible, the extremities of the spine will not be unduly raised and no strength is lost, but care must be taken that the leather forming the head-caps is not too thin. Although much of this may seem obvious, it is surprising how few craftsmen give such details full attention. Many men, either because of laziness or as a time-saver, leave out some of the operations connected with their work; on other occasions they thoughtlessly do more than they need. A case in point is that of paring leather for a half-bound book. On most occasions all that need be reduced is the spinal section and the two turnins, leaving at full thickness the part which lies flat on the sides. One usually finds, however, that the leather has been pared all over, making it harder to the touch and cheaper-looking to the eye. Often, half the beauty of the grain has been diminished in the process.

The foregoing, although but a brief outline of the facts of bookbinding, should serve to emphasise that scale is as important in the design of book construction as it is when used in its more artistic sense. No amount of skill can compensate for faulty judgment in this respect. I use the word "skill" in the place of "craftsmanship" because I feel that there can be no craftsmanship without a full appreciation of scale and its implications. These are the bones of the subject which every craftsman and handicraft teacher should understand. Deftness of manipulation is useless on an unsound structure.

# BOOKSHELF

## DIRECTORY OF PRINTERS' AND BOOKBINDERS' SUPPLIES

To commence a Directory of this nature from scratch is no easy task and in the 384 pages of this book a very substantial collection is brought together No doubt the next edition will have collected more data but as a commencement this book will prove most useful to printers generally. With an attractive green shade of linen cover the contents are alphabetically arranged under seven sections: Composing room, duplicate plate making, letterpress machine room, lithography and photolithography, binding, trade work and supplies and miscellaneous.

It is published by Charles Skilton Ltd., 50, Alexandra Road, London, S.W.19, at 15s.

## PAPER AND PRINTING MANUAL

In his foreword to this excellent and useful book Mr. Fredk. T. Day, an authority on paper and all its implications, makes a plea for better co-operation between paper makers and printers.

It is with a better understanding each of the other's problems that this co-operation can best be achieved and with this end in view this book has been written.

Divided into two parts, the first covers every aspect of paper; its history, ingredients and processes of manufacture, the machines and varieties of paper, converting, testing, sampling, sizes and standard measurements, storage, etc., and runs to 132 pages.

The second half is devoted to printing, block making, type, inks and the value of colour, lay-out and notes on varied printed matter. Finally, a code of ethics for the stationery trade—Paper Trade Customs. A very comprehensive index concludes the contents.

The book is nicely produced with a green linen cover and gold blocked titles. Pages are well printed and fully illustrated on white art paper.

Published by Trade Journals Ltd., London, E.C.4, at 20s., the book will be of very great use to the student and to those who wish for closer and better understanding of the problems of paper and print.

## HOW TO PLAN PRINT

This second edition, revised and reset, of John C. Tarr's book is very welcome.

In every phase of print whether leaflet or most expensive book, *layout* is the fundamental bedrock on which its success or failure finally depends.

Mr. Tarr begins at the beginning and in word and example lays before the reader the means of successful print planning. Today's production methods demand greater co-ordination between designer and printer. Loss of time increases costs and lessens productivity, both factors which must be avoided more than ever today.

This book is divided into three chapters:

1. *Typographical Printing Surfaces*, which includes type, illustration and reproductive processes.
2. *Arrangement* includes design, harmony, colour, proportions, borders, initials, rules, etc., and
3. *Practical Designing for Print* which includes amongst others, the typography of books, advertising, etc., methods of printing, layout and lettering, estimating, type faces, paper sizes and finishes, and printing inks.

The book concludes with a note on present day tendencies, a bibliography and index. It is cloth bound and published by Crosby, Lockwood and Son, Ltd., London, at 12s. 6d.

206

THE BRITISH & COLONIAL PRINTER

MARCH 20, 1953

# THE BRITISH MUSEUM BINDERY

## Great Interest and Variety for Craftsmen

### By BERNARD C. MIDDLETON, FRSA

THE British Museum was first opened in Montagu House in 1759, and until its demolition in 1845 it is probable, though not certain, that the bindery was established in the basement. The present buildings, designed by Robert Smirke, were erected between 1826 and the early 1840s, starting with the King's Library, which was designed to house the collection of George III.

When old Montagu House was destroyed a new bindery was established in an outbuilding by Montagu Street. This was demolished when the White Wing was erected in 1885, and was rebuilt in a yard at the north-west corner of the museum, where it still serves the purpose for which it was built.

**Under the provisions of the Foundation Act it is laid down that no books should be removed from the premises, and this has been interpreted literally to mean that all binding should be done within the precincts. Such has been the practice, though in 1862 there was so much work to be done that some of it was sent out to a binder in Great Russell Street.**

#### RESTORING THE LIBRARY

Until 1927 the work of binding and restoring the museum's incomparable library was contracted out to private concerns. The earliest (1760-73) was Cook, whose bindery must have been small, since he had only two apprentices at the time he was working for the museum. He was followed by Elliot and then Pipping. Charles Tuckett was responsible for the binding between 1825 and 1865; he was followed by his son Charles, who worked until 1875. The Tucketts were well known in the early Victorian period and their 50-year period was a golden one for the museum. There are many bindings in the library which testify to the very high degree of skill attained by their workmen, but unfortunately, as I know from personal experience, some examples have had to be re-bound or re-covered because the leather with which they were covered had perished. I have in mind, particularly, a fine set of upwards of a 100 fat, large-quarto size tomes, covered with russia leather and beautifully tooled with broad-mitred panels. Many hundreds of hours were devoted to their execution, yet in 1948 they had to be re-covered. Such is the tragedy which has overtaken innumerable examples of the unsurpassed craftsmanship of the Victorian binders, and will, no doubt, continue to occur.

Darby and Would continued until 1881; then Eyre and Spottiswoode were responsible until HM Stationery Office took over in 1927, and retained their staff because in the ordinary way they could not satisfy the library's demands for highly-specialised craftsmen.

During the slump in the thirties the staff was implemented by many first-class binders

*The author of this article, well known today as a fine bookbinder, was himself apprenticed at the British Museum Bindery and worked there for nine years. He is therefore well qualified to write about this unusual and nationally important section of the bookbinding industry.*

from Riviere's, Sangorski & Sutcliffe's, Morrell's, Kelly's and other well-known London binderies. Some of these craftsmen have remained, but others have died, retired or been transferred to posts in other departments of the Stationery Office, such as the House of Lords Bindery. A few have joined the technical staff, while others have gone back to the West End binding trade or into teaching.

The bindery is a substantial brick-built structure, two storeys high, about 100 yards long and 20 yards wide. The ground floor consists of a large hall with small rooms at each end for the officer in charge, C. E. Whitehouse, and stock rooms, etc. This main workshop is devoted to forwarding and the more advanced preparatory work for sewing, such as map-lining, and guarding plates with linen. More about this later.

The upper floor is divided into two main workshops—each about half the size of the one below—with smaller rooms at each end. One of the large rooms is occupied by the finishers and the menders, the two departments being ranged down each side of building by the windows. The other one is occupied by the women's department.

Twenty-four forwarders and two collators work in the forwarding department. Each of the forwarders works on a lying press (usually, and ungrammatically, known as 'laying' presses) and tub covered with a large wooden board which serves as a bench and can be slipped off as necessary when the press is required for use. Each is separated by a few feet from the ones next to it, and each is placed, as far as possible, before a window. Several large and seemingly ancient standing presses are ranged lengthways down the middle of the room near the Furnival and Conqueror power guillotines, which are placed right in the middle. On the other side of these machines is a rolling press, beyond which are two iron standing presses which are used by the collators for all books after they have been tapped out and rolled. This combination of rolling and pressing certainly produces a solid book.

Most of the ordinary straightforward books that pass through the bindery are graded into Class I, II or III, for binding purposes. The specification for the first is that they should be sewn on raised cords (except where the books happen to be very small and/or thin), and that they should be covered in full or half morocco with cloth sides and that they should be head-banded and have overcast cloth joints. The morocco is usually of the hard-grain variety. Class II books are sewn on recessed cords, and are covered with half straight-grain morocco, without raised bands or headbands. Normally they are given tight backs. Books in the lowest grade are covered with full cloth or half buckram with paper sides and a hollow back. Until recent times they were always sewn on recessed cords, and the boards were drawn on, but now they are sewn on tapes which go across a French groove.

#### TIME-HONOURED PRESS

As we have seen, books in the first grade are given cloth-jointed endpapers, which until recently were made up with brown Cobb paper lined with white, but now they are entirely white. Fore-edges are trimmed in the guillotine, but heads and tails are cut by the time-honoured press and plough process. They are then sprinkled and burnished.

Books in the other grades are also sprinkled, but they are left unburnished.

The majority of the 2,000-odd volumes that go through the bindery each month are bound for the General Library. They are studied in the world-famous Reading Room where many of the country's greatest men of letters and science have at some time worked, or in the North Library where the more valuable books and larger tomes are consulted.

Most of the books are obtained by the readers on application to the Centre Desk,

*continued on page 353*

351

THE BRITISH & COLONIAL PRINTER MARCH 20, 1953

# THE BRITISH MUSEUM BINDERY

*continued from page 351*

but many thousands of the more commonly used works of reference are housed on the open shelves. Because they are in such demand they are given priority in the bindery, and they are usually bound in Class I style.

As a general rule, books printed more than a 100 years ago are not trimmed, but for various reasons this ruling is often modified.

Apart from the General Library many books are bound for the various departments, such as the Greek and Roman, British Medieval, Oriental MSS, Prints and Drawings, Coins and Medals, and so on. The styles of binding are much the same, except that those in half morocco are sewn on recessed cords. Several men are constantly engaged on the repair of manuscripts and making them up into compact volumes for the Department of Manuscripts.

## FORTUNATE FORWARDERS

The forwarders are fortunate compared with many of their friends in the trade because they forward *and* cover the books. The normal division of labour results in higher production figures, but non-division has the advantage of greater interest and variety for the craftsman, and, no doubt, that interest is reflected in the standard of craftsmanship and is to the advantage of the management in the long run.

In addition to routine binding, the department handles repairs and boxmaking —mostly slip-cases and drop-back boxes for the more valuable books and interesting examples of binding. Re-backing is carried out in the usual way with the original spine preserved when possible, but it is the practice to overcast a strip of cloth or linen along the joints and to sharpen them up in the lying press before the boards are re-attached. The last operation is to lift the original endpapers along the joints and to paste the linen down underneath, after which the endpaper is pasted down on top of the linen. The result is more noticeable than the trade practice of pasting paper to match along the edge of the board in the joint, but, of course, it is very strong, and that is the chief consideration. For the same reason calf bindings used to be re-backed with goatskin, but this is another rule that has been relaxed.

## PRESERVING EARLY MSS

Early papyrus MSS, because they are invariably very brittle and delicate, are preserved between two sheets of glass which are bound together at the edges with leather. The two great advantages of the method are that the manuscripts are kept perfectly flat and they can be seen without difficulty on both sides.

It has already been mentioned that the more complicated pre-sewing work is done by male collators in this workshop, and not by women as is more usual in the trade. Lining maps with jaconet is one of their tasks. As a general rule they are not lined at all unless there are right-angle folds, and they are not dissected unless there are more than four folds in on the head and tail. The number of folds on the fore-edge does not matter because they are zig-zagged, thus eliminating bunching in the folds.

A few yards away on the other side of a courtyard, in the main museum block, is a small bindery where the 'French' binders work. The designation 'French' is in use only in the museum, and its origin is somewhat obscure; it may be derived from the fact that the small group of binders who work there have always been engaged in putting temporary covers on tracts, cheap novels and duplicates. At any rate, it bears no relation to the nationality of the binders concerned, except, possibly, by coincidence.

### GILT LETTERING

Upstairs, in the finishing department, there are nine finishers. In the ordinary course of events their work is limited to titling, gilt lines across the spines and centre tools. Much of the lettering on the best leather work is still done with hand-letters, and in this respect the finishers are probably the best in the country. Assistant-finishers, who work at the far end of the line of finishers, are responsible for siding and pasting down.

Behind the finishers, on the other side of the room, are the 11 all-male menders whose function is to mend but not to deceive. The value of their labours is that the damage already inflicted will not accidentally be extended by readers in their avid quest for knowledge; therefore, the renovations are effected neatly and congruously, but not in a manner that could, in years to come, result in the repair being regarded as original work.

### ANCIENT BOOKS

Where ancient books are concerned the museum's demands are somewhat different from those of many private collectors who, too often, are more interested in having good showpieces than in handing down to posterity the nation's treasures in a lasting and unfaked condition. In my experience very few collectors are deterred by the possibility of deleterious consequences arising from the use of acids for the removal of fox-marks and other stains, but the museum menders are forbidden to use it.

Their work also includes making up the backs of sections damaged (as is sometimes inevitable) when the books are pulled, and gauzing fragile leaves to give them increased tensile strength. Some weak leaves are rejuvenated by immersion in a size bath, the original size having perished and left little to hold the fibres together. Sizing sometimes helps to even out whatever water stains there may be in addition to being a strengthener, but care must be taken not to make it too thick lest the paper should become brittle as it dries.

In pre-war days (when the mending staff was larger than it is now) the amount of work to be done was enormous, but war damage to the library considerably increased the number of books needing attention.

Apart from those damaged, it has been calculated that about a quarter of a million volumes were destroyed. Much of the damage was caused by the firemen's water —books printed on art paper became solid blocks and were quite beyond repair.

In the women's department there is a staff of 34 that does the pulling, collating and sewing on tapes and cords, both recessed and raised. They also overcast on the cloth joints after the books have been sewn and the endpapers have been attached.

One of their tasks which occupies much time is the lining of weak pages with tissue —on both sides, of course, to avoid a one-sided pull. The more valuable books are lined with French silk gauze by the menders.

### NEWSPAPER BINDING

During the earlier years of the century it was the practice to store newspapers at Colindale, and they were sent to Bloomsbury when asked for by readers. In 1932 the repository was enlarged and a reading room and bindery were opened. The binding staff of eight men and eighteen women, in common with the Bloomsbury staff, are employed by HM Stationery Office and are under the supervision of Mr Whitehouse.

The museum's examiner of bindings is H. Phillips, who received his early technical training at the Central School of Arts and Crafts, and worked at the renowned firm of Robert Riviere for about 20 years before he went to the British Museum as a binder at the bench. At his instigation, with the support of H. M. Nixon, assistant keeper in charge of bindings, and Mr Whitehouse, a start has been made on some 'extra' bindings. They are gilt-edges, covered with Levant morocco and tooled to modern designs worked out by the staff. Flyleaves and doublures are sometimes of leather, and the bindings are contained in half morocco boxes. Although the extent of this work is at present limited by the need for financial economy, it is a most desirable development, because, as a craft bindery, it is one of the most important establishments in the world, and it is only right and appropriate that it should produce at least a small quantity of work in styles and materials that show off the craft to its best advantage and represent the world-famous library and its bindery in a fitting manner.

353

# BIBLIOGRAPHY

The following is a personal listing, and is not intended to conform to standard bibliographical practice. It is an amplified version of a list I supplied for Dorothy Harrop's series "Craft Binders at Work" in *The Book Collector*, Autumn, 1977, and which was revised for the first edition of my *Recollections* (1995).

## ARTICLES AND BOOKS BY BERNARD C. MIDDLETON

'Scale in Bookbinding', in *Paper & Print*, Summer 1950.

Appendix II: 'Glass'. 'The Lullingstone Roman Villa' in *Archaeologia Cantiana*, vol. LXIII, 1950.

'Deterioration of Bookbinding Leather', in *Paper & Print,* Autumn 1950.

'Book Endpapers and their Attachment', in *Paper & Print*, Winter 1950.

'Bookbinding by Amateurs for Hospital Patients', in *The British & Colonial Printer*, 23 March 1951.

'LSP Bookbinding Designs at NBL Exhibition', in *The British & Colonial Printer*, 23 March 1951.

'Notes on the Hand Sewing of Books', in *Paper & Print*, Spring 1951.

(With Max Unwin). 'An Improved Leather Dressing' in *Museums Journal*, June 1951.

'Bindings in the Exhibition of Books at the Victoria and Albert', in *The British & Colonial Printer*, 8 June 1951.

'Engraving for the Decoration of Fine Bindings', in *The British & Colonial Printer*, 15 June 1951.

'Further Notes on the Hand Sewing of Books', in *Paper & Print*, Summer 1951.

'Bindings in the Exhibition of Ecclesiastic Art at Lambeth Palace', in *The British & Colonial Printer,* 13 July 1951.

'The Supported French Groove', in *The British & Colonial Printer,* 10 August 1951.

'Bindings at the Central School of Arts & Crafts Give Hope for Future', in *The British & Colonial Printer*, 10 August 1951.

'The Birth of a Book', in *The British & Colonial Printer,* 7 September 1951.

'Fine Bindings at the South Bank', in *Paper & Print,* Autumn 1951.

'Notes on the Repair of Books', in *Paper & Print*, Autumn 1951.

'The Trade versus The Rest', in *The British & Colonial Printer*, 2 November 1951.

'Young Guild at Hampstead Holds First Bookbinding Exhibition', in *The British & Colonial Printer,* 2 November 1951.

'English Bookbinding Literature', in *Paper & Print*, Winter 1951.

'English Bindings at the Bibliothèque Nationale', in *The British & Colonial Printer*, 25 January 1952.

'Notes on Craft Bookbinding in Paris', in *The British & Colonial Printer*, 22 February 1952.

'English Bookbinding in 1951', in *Paper & Print,* Spring 1952.

'Fine Bindings: the present and the future', in *The British & Colonial Printer,* 21 March 1952.

'Controversial Thoughts on the Decoration of Fine Bindings', in *The British & Colonial Printer,* 16 May 1952.

'Rounding and Backing', in *The British & Colonial Printer*, 11 July 1952.

'Binding and Repair of Books: great voluntary effort by St. John and Red Cross', in *The British & Colonial Printer*, 18 July 1952.

'Rounding and Backing' (Pt 2) in *The British & Colonial Printer*, 8 August 1952.

'The Technique of Pasting Down Endpapers', in *The British & Colonial Printer,* 5 September 1952.

'Notes on the Art of Covering with Leather', in *Paper & Print*, Autumn 1952.

'Brilliant French Craft Binding . . .', in *The British & Colonial Printer*, 31 October 1952.

'Royal Stamp Volume: binding problems and their solution', in *The British & Colonial Printer*, 28 November 1952.

Appendix III: 'The Glass'. 'The Lullingstone Roman Villa' in *Archaeologia Cantiana*, vol. LXV, 1952.

*Notes on the Art of Bookbinding* (anon. Zaehnsdorf Ltd., 1952).

'Distinguished Shopping; Craft Bookbinding', (anon.) in *The Diplomatist*, December 1952.

'Notes on the Art of Covering with Leather' (Pt 2), in *Paper & Print*, Winter 1952.

'Boxes and Cases for Books', in *The British & Colonial Printer*, 23 January 1953.

'The British Museum Bindery', in *The British & Colonial Printer*, 20 March 1953.

'Craft Bookbinding in 1952', in *Paper & Print*, Spring 1953.

'Is the Crafts Centre Really Effective?', in *The British & Colonial Printer*, 3 April 1953.

'Craft Bookbinding in England', in *British Craftsmanship*, Coronation Number, 1953.

'Ephemeral Bookbinding Literature', in *The British & Colonial Printer*, 10 July, 7 August, 4 September 1953.

'The Zaehnsdorf Story', in *The British & Colonial Printe*r, 25 December 1953, 22 January, 19 February 1954.

'Craft Bookbinding in 1953', in *Printing World*, 19 March 1954.

'Modern and Historical European Bindings in London', in *Printing World*, 11 June 1954.

'Craft Binding Technique', in *Printing World*, 29 September, 27 October, 24 November 1954.

'Two Bookbinding Exhibitions', in *Printing World*, 27 October 1954.

'The Gwynn Family', in *Printing World*, 26 October, 23 November, 21 December 1955.

'Cakes and Ale'. Anon. Leader in *Printing World*, 2 April 1956.

'Craftsmanship'. Anon. Leader in *Printing World*, 9 May 1956.

'American Bindings of the Finest Quality', in *Printing World*, 9 May 1956.

'Early 19th-Century Binding Manuals and Techniques', in *Printing World*, 4 July 1956.

'A Living Craft'. Anon. Leader in *Printing World*, 1 August 1956.

'Old Books'. Anon. Leader in *Printing World*, 4 September 1956.

'Hand-bound Books Should Influence Taste in Contemporary Design', in *Printing News*, 6 September 1956.

'A Rare Bookbinding Manual', in *Printing World*, 12 December 1956.

'The Furbishing of Leather Bindings', in *Printing World,* 19 December 1956.

'A Book Craftsman Retires—Frank Bull' in *Printing World*, 13 March 1957.

'English Craft Bookbinding', in *Printing World*, 13 February, 13 March, 10 April, 8 May 1957.

'Today's Trends in British Bookbinding Design', in *Paper & Print*, Summer 1957.

'Fine Binding: a craft and its craftsmen', in *The Penrose Annual,* 1958.

'The Bookbinder's Case Unfolded', in *The Library*, March 1962.

'The Gwynn Family of Edge-Gilders", in *The Book Collector* (Note 190), Winter 1962.

*A History of English Craft Bookbinding Technique* (London: Hafner 1963); 2nd, supplemented ed. 1978, new Introduction 1988 (Holland Press). 4th ed. (Oak Knoll Press and British Library 1996).

*The Restoration of Leather Bindings* (Chicago: American Library Association 1972). Revised edition 1984 3rd ed. (Oak Knoll Press and British Library 1998).

*An Exhibition of Modern British Bookbindings by Members of Designer Bookbinders, Pierpont Morgan Library, New York, October/November 1971; Newberry Library, Chicago, January/February 1972; University of California, Los Angeles, March 1972; Victoria and Albert Museum, June/July 1972.* Document 1.

'Craft Binding—Complexities and Influences', in *Designer Bookbinders Review*, Spring 1973.

*Designer Bookbinders 1974.* The catalogue of an exhibition held at the Craft Advisory Committee's Waterloo Place Gallery, July 1974, and at Edinburgh University Library, August/September 1974. Foreword to catalogue.

'Old vs. New: a division of interest', in *Designer Bookbinders Review*, No. 8, Autumn 1976.

'Facsimile Printing', in *The Paper Conservator*, Vol. 1, 1976 (IIC UK Paper Group).

Review of Eric Burdett. *The Craft of Bookbinding* in *The Paper Conservator,* volume 1, 1976.

'Book Preservation for the Librarian', in *Preservation of Paper and Textiles of Historic and Artistic Value* (The American Chemical Society 1977).

*Two Modern Binders: William Matthews & Edgar Mansfield.* Victoria & Albert Museum exhibition catalogue. 1978 'Edgar Mansfield'.

Review (with Denise Lubett) of Dudin, M. *The Art of the Bookbinder and Gilder* in *Fine Print*, October 1978.

'American Restoration Binding Today: An English Perspective', in *The Abbey Newsletter*, April 1979.

Hunt Institute for Botanical Documentation, Pittsburgh, Penn., 1979. *The Tradition of Fine Bookbinding in the Twentieth Century.* Foreword to exhibition catalogue.

John Andrews Arnett. *Bibliopegia; or, The Art of Bookbinding in all its Branches.* 1835 (reprinted by Garland Publishing, Inc. 1980). Introduction.

'The Tradition of Fine Bookbinding', in *The Library Scene,* June 1980.

'English Craft Bookbinding, 1880–1980', in *The Private Library,* Winter 1981. Reprinted in *The Guild of Book Workers Journal*, Fall/Winter 1983.

Designer Bookbinders. *The New Bookbinder*, volume 1, 1981. Introduction. Review of A. D. Baynes-Cope. *Caring for Books and Documents.*

'The Gwynn Family', in *The New Bookbinder,* volume 3, 1983. Adapted from a series of articles in *Printing World*, 1955.

'The Development of Bookbinding Techniques' in *Contemporary Designer Bookbindings; Europe & Australia* (Crafts Council of Australia 1984). Exhibition catalogue.

Kerstin Tini Miura. *My World of Bibliophile Binding* (University of California Press, 1984). Foreword.

Anne Chambers. *Marbled Papers* (The Cygnet Press 1984). Introduction.

Review of Ivor Robinson. *Introducing Bookbinding* in *The New Bookbinder*, volume 5, 1985.

Anne Chambers. *The Practical Guide to Marbling Paper* (Thames & Hudson 1986). Introduction.

Obituary of Sydney M. Cockerell in *The Independent,* 10 November 1987.

*The Whole Art of Bookbinding* and *The Whole Process of Marbling Paper* (W. Thomas Taylor: Austin 1987). Foreword to each book.

'In Memorium: Sydney Morris Cockerell' in *Ink & Gall*, Spring 1988.

*A Bookbinders' Florilegium* (The Press at the Humanities Research Center: Austin, Texas 1988). A contribution.

'Brief History and Activities of the Society', in *DB 5; an Illustrated Directory of Fellows and Licentiates of Designer Bookbinders* (Designer Bookbinders 1989).

*The Binder's Art, Catalogue of an Exhibition of Highlights from the Bernard C. Middleton Collection of Books on Bookbinding* (Rochester, New York 1989). Foreword.

Maggs Bros. Ltd. Catalogue 1098. *Book Binding.* Summer 1989. Introduction.

Obituary of Lionel Darley in *The Guardian,* November 10, 1990.

'Roger Powell: an appreciation', part of 'A Tribute to Roger Powell', in *The New Bookbinder*, volume 11, 1991.

'Blunders and Set-backs', in *Bookbinder* (Society of Bookbinders), volume 6, 1992.

'The Gold Tooling of Books', *Interdisciplinary Science Reviews*, volume 17, No. 4, 1992.

'Working with American Bookbinders and Restorers: A View from Abroad', in *The Book Club of California Quarterly News Letter*, Summer 1993.

Review of Samuel B. Ellenport. *The Future of Hand Bookbinding* in *The New Bookbinder*, volume 13, 1993.

'A Century of Developments in Restoration Binding' and 'Bernard Middleton on William F. Matthews', in *The New Bookbinder,* volume 14, 1994.

*You Can Judge a Book by its Cover*. Miniature book (Kater Crafts Bookbinders, 1994).

*Recollections: My Life in Bookbinding* (Newtown, Penn.: Bird & Bull Press 1995). Edition limited to 200 numbered copies.

Review of John Mitchell. *An Introduction to Gold Finishing*, in *The New Bookbinder,* volume 15, 1995.

William Tomlinson and Richard Masters. *Bookcloth 1823–1980* (published privately 1995). Foreword.

Designer Bookbinders. *Tregaskis Centenary Collection Catalogue*. 1995. Article.

'Elizabeth Greenhill at Ninety', in *The New Bookbinder*, volume 17, 1997.

'The Use of Gold in Bookbinding', in *Twenty-Five Gold-Tooled Bookbindings* (Oak Knoll Press 1997).

'Miniature Binding Problems', in *33 Miniature Designer Bindings* (Kater Crafts Bookbinders 1998).

'Recollections of Life in Bookbinding', in *The New Bookbinder*, volume 18, 1998.

'The Evolution of British Fine Binding c. 1770–c. 1840' in *Ticketed Bookbinding from Nineteenth-Century Britain*, Willman Spawn & Thomas E. Kinsella. (Oak Knoll Press and Bryn Mawr College 1999).

Review of William Tomlinson & Richard Masters. *Bookcloth 1823–1980* in *The New Bookbinder*, volume 19, 1999.

Highlights from the Bernard C. Middleton Collection of Books on Bookbinding. (Cary Graphic Arts Library, Rochester Institute of Technology, NY 2000). Compiled exhibition catalogue.

## ARTICLES ON THE WORK OF BERNARD C. MIDDLETON

'Banden van Bernhard Middleton', in *Magnus*, August 1959.

Howe, Ellic. 'Bernard Middleton: solitary craftsman', in *Printing News*, 22 September 1955.

Mansfield, Edgar. 'Bernard Middleton in London', in *Allgemeiner Anzeiger für Buchbindereien*, January 1957.

Nixon, Howard M. 'Binding by Bernard C. Middleton', in *Broxbourne Library: styles and designs of bookbindings from the twelfth to the twentieth centuries*. (Maggs Bros. for the Broxbourne Library 1956).

'Wisdom from the Abbey is Preserved for the Future', in *The Star*, 25 January 1957.

Dorothy A. Harrop. 'Bernard Chester Middleton': Craft Binders at Work VIII, in *The Book Collector,* Autumn 1977.

Frank Broomhead. 'Profile: Bernard Chester Middleton M.B.E.', in *Bookbinder*, volume 2,   1988.

Sheila Markham. 'Period Piece; Bernard Middleton in conversation with Sheila Markham', in *Bookdealer*, No. 1249, 21 March 1996.

## VIDEOS

'Binder: A Portrait of Bernard Middleton', an "Alms and the Man" Production, 1990.

'Rebacking an Antiquarian Book' in *Binder Vision* No. 2, 1993.

'Ageing New Work' in *Binder Vision* No. 3, 1993.